Images of America
Philadelphia's Broad Street
South and North

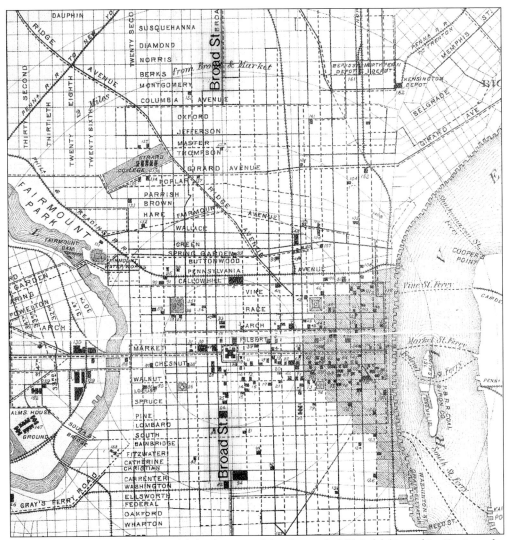

This map of Philadelphia was published in a guidebook entitled *Philadelphia and Its Environs* for the 1876 Centennial Exposition. It shows an X at Centre Square, where horizontal Market Street and vertical Broad Street cross. The shaded area to the east of Centre Square was the commercial center of Philadelphia in 1876. By the 1890s, the commercial center had shifted westward to Broad Street, with the building of Philadelphia City Hall on Centre Square and two major Center City railroad stations.

IMAGES
of America

PHILADELPHIA'S BROAD STREET
SOUTH AND NORTH

Robert Morris Skaler

ARCADIA

Copyright © 2003 by Robert Morris Skaler.
ISBN 0-7385-1236-2

First printed in 2003.

Published by Arcadia Publishing,
an imprint of Tempus Publishing Inc.
2A Cumberland Street
Charleston, SC 29401

Printed in Great Britain.

Library of Congress Catalog Card Number: 2003105093

For all general information, contact Arcadia Publishing:
Telephone 843-853-2070
Fax 843-853-0044
E-mail sales@arcadiapublishing.com

For customer service and orders:
Toll-free 1-888-313-2665

Visit us on the Internet at www.arcadiapublishing.com.

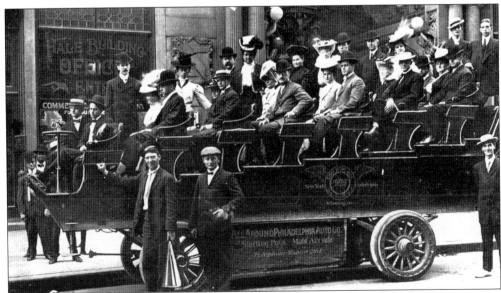

In 1905, you had to pay $1, a day's wages, to take the "All Around Philadelphia Auto Company" Broad Street Tour. The electric bus shown here is in front of the Hale Building, which is still standing at Juniper and Chestnut Streets. The tour went from the Ridgway Library north to Diamond Street and featured many places of interest also shown in this book.

Contents

Preface		6
Introduction		7
1.	South Broad Street: Navy Yard to South Street	9
2.	South Street to Penn Square	21
3.	Penn Square	49
4.	North Broad Street: Penn Square to Master Street	61
5.	The Grand Promenade: Master Street to Susquehanna Avenue	97
6.	Huntingdon Street to Old York Road	119
Acknowledgments		128

Preface

Broad Street is like a coring tool running through the tree of Philadelphia history. Starting at city hall and moving either north or south, one can see the changes that occurred in the city's development and social history. Both South and North Broad Streets are examples of the successes and failures of urban design in the last 100 years. Vintage photographs of the street show an active social vitality that is sadly missing from some areas of Broad Street today, especially to the north, but is slowly returning to others. Broad Street, starting on the south from Washington Avenue and extending north to Lehigh Avenue, is now called the "Avenue of the Arts." Both South and North Broad Street buildings have benefited from being historically certified. Many of the 19th- and early-20th-century buildings have been restored, adding great interest and a human connection to the streetscape once again. Because so much of the historic fabric of North Broad Street has been demolished, it has been difficult to make it as socially active and viable as its southern counterpart.

Whenever possible, I have identified when a building was built and who was the architect. The scope of this book is limited to images relating to Broad Street, with three important exceptions: the Girls' High School, the Wagner Free Institute of Science, and Shibe Park. Most of the images contained herein date from the turn of the century, but some later images have been included because of their importance to Broad Street's social history. This book's format is similar to an architectural guidebook, organized from south to north rather than chronologically, and can be used as such to identify historical buildings that have survived into the 21st century or to ponder over the irretrievable architectural heritage that has been lost.

—Robert Morris Skaler

INTRODUCTION

Philadelphia's Broad Street is the longest straight city street in the world, reaching from the navy yard on the south to the city limits on the north, a distance of over 12 miles, with a width of 113 feet for the entire length. It was one of Philadelphia's premier streets from 1876 to 1915 and is still one of the city's major thoroughfares. Broad Street was laid out by William Penn's surveyor, Thomas Holme, who made the first map of Philadelphia showing Broad Street as the major north-south street, intersecting with High (Market) Street at Centre Square in the heart of the city. Broad Street addresses are numbered either south or north of Market Street. As you travel south on Broad Street, starting at 1900 south, the cross streets are named in honor of successive governors of Pennsylvania until you reach Pattison Avenue. North Broad's cross streets are named for Pennsylvania counties, starting at Berks Street, 1900 north, and ending at Lycoming Street, 4100 north.

South Broad Street began to develop as a cultural street with the building of the ornate Academy of Music in 1857. After the Civil War, the trend continued with the construction of the Ridgway Library, the Union League, Horticultural Hall, and the Broad Street Theater. By 1910, South Broad Street had become known as "Hotel Row," with five prominent hotels within a few blocks of one another. South of Hotel Row was "Millionaires' Row," which consisted of several blocks of huge, lavish brownstone houses. Broad Street was also the favorite street for parades and celebrations, notably the annual New Year's Day Mummers' Parade.

Where Broad and Market Streets cross at Centre Square—the largest of the original five open squares in the city—construction began in 1871 on the largest municipal building in the country: the Second Empire–style Philadelphia City Hall. It was later flanked by the Pennsylvania Railroad's massive Broad Street Station. The opening of the Broad Street Station and the new city hall shifted the center of the commercial city from colonial Society Hill to Broad Street. The street became the site for the Land Title Building in 1897, Philadelphia's first modern skyscraper; the luxurious Bellevue Stratford Hotel in 1902; and John Wanamaker's huge flagship department store in 1911.

After the railroad tracks were removed from Broad Street in the 1860s, development began on North Broad Street with the construction of the Masonic Temple, and later, the Pennsylvania Academy of Fine Arts in 1876. Numerous churches, synagogues, hotels, schools, and private clubs were built, making it a major promenade in the 19th century. By 1876, the city's development expanded northward with the horsecar trolley lines, and North Broad Street became lined with the elegant brownstone mansions of Philadelphia's industrialists and

businessmen. Among the homes were those of Edwin Forest, America's first professional actor and father of theater in Philadelphia; Michel Bouvier, cabinetmaker and ancestor of Jacqueline Bouvier Kennedy; department-store owner Ellis Gimbel; industrialist Henry Disston; and traction magnates and philanthropists P.A.B. Widener and William Elkins. North Broad Street also became the center of social life for upper-class German Jews, who built four major synagogues on North Broad Street and the impressive Mercantile Club.

While prosperous, North Broad Street was never really fashionable. It did not have the cachet of the areas south of Market Street, which was home to Philadelphia's traditional elite class ensconced around Rittenhouse Square. Perhaps to compensate for this lack of social standing, residents of North Broad Street built their houses grander than any in Center City, preferring the clean uptown air to that of the old Quaker City, with its cramped space and hurly-burly.

By 1908, North Broad Street had reached its summit with the opening of the Metropolitan Opera House. There were also places of learning like the Wagner Free Institute, the new Central High School, the Girls' Normal School, Roman Catholic High School, La Salle College, the Spring Garden Institute, and Temple University. Farther north, Broad Street was still undeveloped and held room for two baseball parks—Shibe Park, home of Connie Mack's Athletics, and the Baker Bowl, home to the National League. At its extreme northern end was the new Widener School for Crippled Children and the Jewish Hospital.

Ironically, the building of the Broad Street Subway in 1924, which greatly enhanced the development of South Broad Street as a major commercial street, dealt a deadly blow to North Broad Street—especially south of Lehigh Avenue—as a premier residential neighborhood. The dust and noise of the work crews sent wealthy matrons fleeing to the suburbs, and their homes were recycled into offices, catering establishments, and funeral parlors. Only a few remnants of North Broad Street's gilded age are standing today. Fortunately, this lost period in the street's development has been documented in vintage postcards and photographs, many of which appear in this book for future generations to explore.

One
SOUTH BROAD STREET: NAVY YARD TO SOUTH STREET

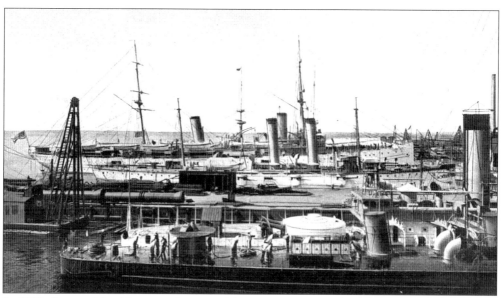

In 1875, League Island became the second home to a navy yard. This 1905 postcard shows a variety of ships docked at the yard. Until the building of League Island Park and the Sesquicentennial Exposition of 1926, undeveloped land existed from Oregon Avenue to the navy yard's gates. The navy yard was once a major economic force in Philadelphia as the area's largest employer.

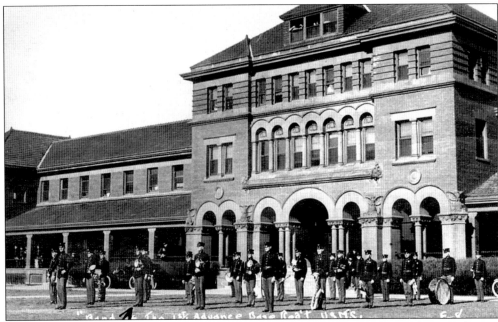

The U.S. Marine Corps 1st Advance Base Regiment Band of the navy yard is standing in formation in front of one of the League Island's navy headquarter buildings (built c. 1901) in this 1915 photograph. The navy moved to the western end of League Island in the 1990s. These historic buildings are now being restored into commercial office space.

Philadelphia's "hoagie" sandwich probably got its name from the homemade sandwiches these Hog Island ship workers ate. When this 1905 postcard was made, the American International Shipbuilding Corporation at Hog Island was the largest shipyard in the world. Two other giant shipyards, William Cramp & Sons Shipyard in Kensington and the navy yard on League Island, helped Philadelphia shipyards set records for shipbuilding production during World War I.

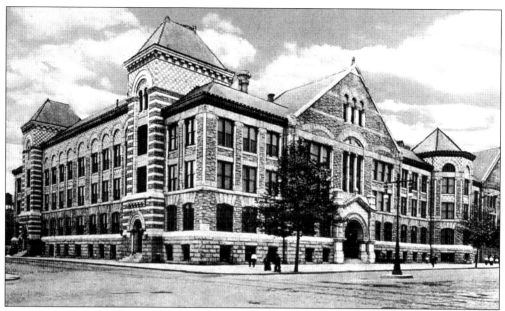

Seen above is the Southern Manual Training School, at Broad and Jackson Streets, which was built in 1907. Architect Lloyd Titus designed it in a massive Romanesque style that was made popular by Boston architect H.H. Richardson in the 1880s and considered a favorite style of the Philadelphia School Board for its indestructibility. Below is a 1907 postcard view of the school as seen from Broad and Snyder Avenue. In 1915, the building became South Philadelphia High School.

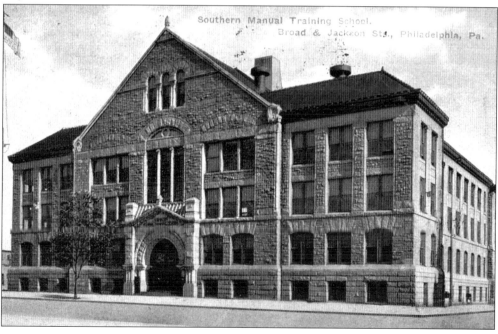

Methodist Episcopal Hospital, still located at the southeast corner of Broad and Wolf Streets in South Philadelphia, was nonsectarian, open to all socioeconomic classes, and free to the indigent. It was founded by the bequest of Dr. Scott Steward, a Philadelphia physician. Shown in this 1905 postcard is the Charles G. Coulston Memorial Building, which was designed in 1892 by architect Thomas P. Lonsdale in a picturesque Scottish Baronial style.

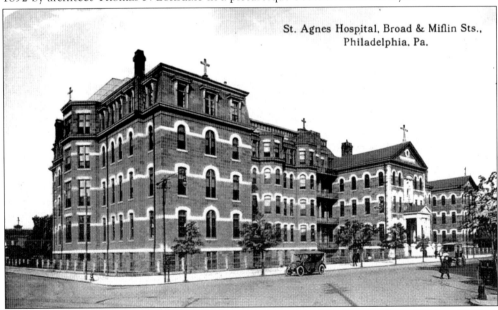

St. Agnes Hospital, which was designed by architect Edward F. Durang from 1880 to 1906, is still located on the southwest corner of Broad and Mifflin Streets at 1900 South Broad Street. The hospital was built to serve the growing numbers of Catholic immigrants who lived in the newly built areas of South Philadelphia. Durang, who also designed churches, festooned the hospital with an abundance of crosses to signify that the hospital was important church property. This postcard view is from 1912.

In 1892, Philadelphia's mayor was Edwin S. Stuart. Stuart's life reads like a Horatio Alger story. He worked his way up from his humble beginnings as an errant 14-year-old boy with only a grade-school education to become the mayor of Philadelphia. He was elected with a larger majority than any mayor before him. His mansion, seen below as it looked in 1898, was located at 1538 South Broad Street.

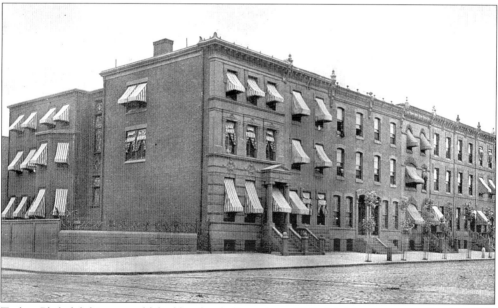

Today, Philadelphians would find hard to believe that a Philadelphia mayor once lived at 1538 South Broad Street, the corner house with the walled side garden. South Broad Street is now very commercial, filled with the constant din of SEPTA buses and traffic—certainly no place for a mayor's mansion. In 1898, however, this upscale residential block was a great place for Mayor Stuart to live; it was only 15 blocks south from his city hall office and removed from the smoke and noise of Center City.

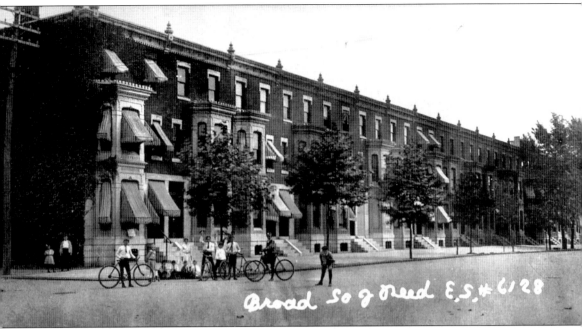

This 1907 postcard shows the east side of South Broad Street below Reed Street. Located south of the industrial hustle and bustle of Washington Avenue, these quiet residential blocks were favored by professionals and later funeral parlors that wanted the prestige of having a Broad Street address. The neighborhood is predominately Italian today, but at the time this postcard was made, the block had almost no residents of Italian descent. Around 1910, South Philadelphia's Italian community was centered farther east, near Seventh and Reed Streets. As the community became more affluent, it began to move west to South Broad Street. St. Rita's Church opened in 1915, and in the next 20 years, this area of South Broad Street became part of Philadelphia's Italian community.

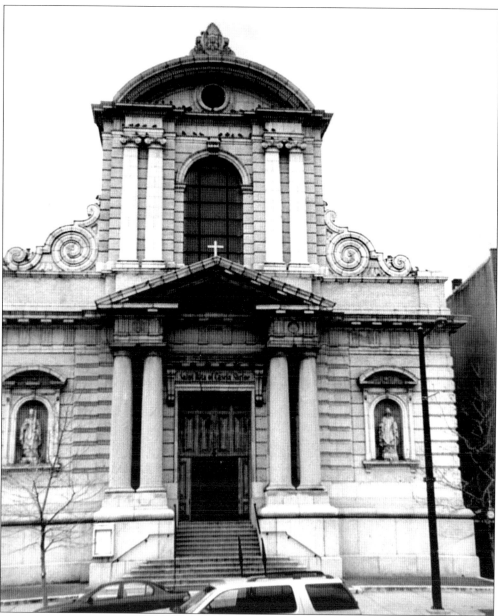

In 1905, Archbishop John Patrick Ryan purchased land in the middle of the block between Ellsworth and Federal Streets to build the Church of St. Rita of Cascia, whose patron had been granted sainthood in 1900. Architect George Ignatius Lovatt Sr. designed a monumental facade in the Roman Baroque style of the 17th century, the century St. Rita was beatified. Construction on the church was begun in 1907 and finished in 1915. The base of the church's facade is limestone; the upper parts are made of cast terra cotta, purposely chosen to stand out from South Broad Street's brick and brownstone row houses. St. Rita was granted a stigmata and became known as the patron saint of impossible cases. She was a source of devotion to the many struggling and poor Italian immigrants who lived in South Philadelphia. Because St. Rita was Italian, the parish evolved from predominantly Irish to a mixed Italian-Irish congregation and, within 20 years, to an all-Italian congregation.

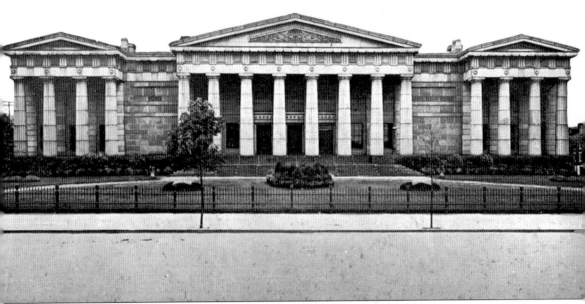

Ridgway Library, Philadelphia, Pa.

The Ridgway Library, at Broad and Christian Streets, is seen in a 1907 postcard view. Philadelphia architect Addison Hutton used a Classical Greek Revival style that was already out of fashion when he designed the library in 1873, or if you wish, was 30 years ahead of its time. Built for the Library Company of Philadelphia from a $1 million bequest by Dr. James Rush, the library was also the tomb for Dr. Rush and his wife, Phoebe, in whose family name the building was dedicated. To protect the library's valuable collection, it had to be fireproof. Unfortunately, the Library Company members never liked the downtown building, and they finally vacated it in 1966, taking the bodies of the Rushes with them. The building was turned into a city recreation center in 1973 and eventually became derelict; it was so covered with graffiti that it was used as a ruined backdrop in the 1995 science fiction movie *Twelve Monkeys*. In 1997, the building was restored and now has a new life as the Philadelphia High School for Creative and Performing Arts. Kise, Straw, and Kolodner designed the restoration.

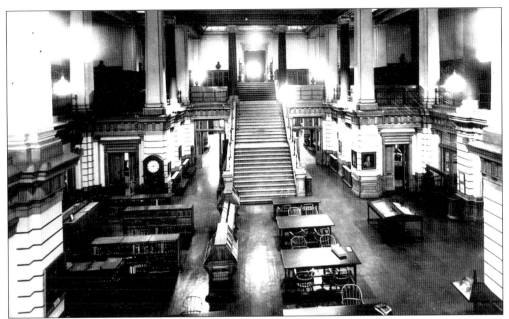

This is the Grand Court of the Ridgway Library as it looked c. 1900. The room's plan is that of a Greek cross with large skylights lighting the balcony areas and reading room below. When it opened on May 6, 1878, it was hailed as being "without a doubt the finest library building in the world" by the Philadelphia journal *Our Continent*. (Courtesy Library Company of Philadelphia.)

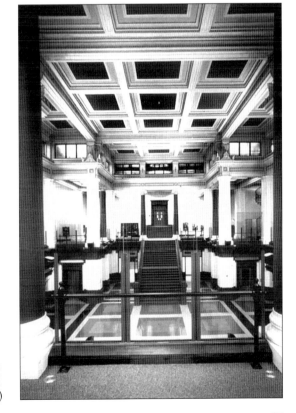

After years of neglect, the Ridgway Library has been completely renovated and expanded to become the new facility for Philadelphia's only magnet school for the arts. The new school opened in November 1997, and the Grand Court, a great example of adaptive use, was expertly restored to its former glory. (Courtesy Kise, Straw, and Kolodner; photograph by Tom Bernard.)

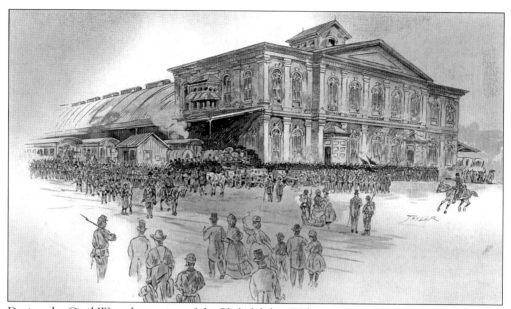

During the Civil War, the station of the Philadelphia Wilmington and Baltimore Railroad was on the west side of Broad Street at Washington Avenue. It was a marshaling point for Union troops going south. This 1861 sketch shows the head house of the station, which is now demolished. Still standing is the curved-roof freight depot, a great cast-iron, single-span structure, visible just behind the head house.

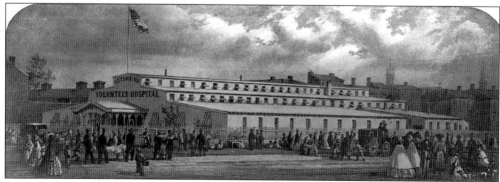

Sick and wounded men of the Union army and navy passing through the city were treated at the Citizens' Volunteer Hospital, which opened in 1863 opposite the railroad station at Broad and Washington Avenue. Fire ambulances carried the wounded from here to local military hospitals. In the 1860s, there were still large tracts of undeveloped land on Broad Street south of Washington Avenue, which was called Prime Street at that time.

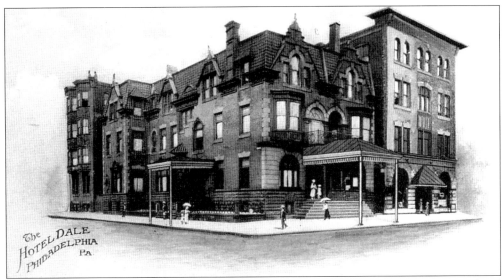

Hotel Dale was made c. 1905 from twin Victorian houses that were built in 1889 at Broad and Catharine Streets. The Christ Gospel Mission Home, which was built in 1897, stood next door. In 1939, Father Divine's followers purchased both properties and renamed them the Circle Mission Church. In 1942, the buildings became the headquarters of Father Divine, who was the charismatic founder and pastor of the Peace Mission Movement. The Circle Mission also ran a popular public dining room and barbershop on the premises.

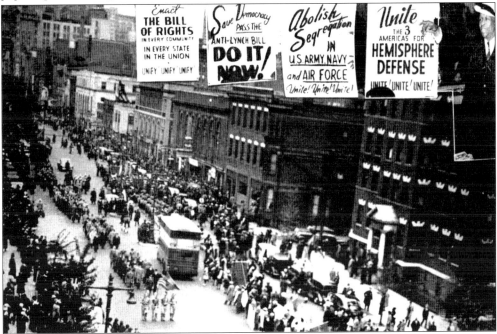

This view looking north on Broad Street from Fitzwater was on the front page of the October 1940 *New Day*, a newspaper published by Father Divine's Peace Mission. The inset in the upper right is Father Divine pointing to the placards used in the parade. Thousands of spectators lined the sidewalks to participate in Father Divine's demonstration against segregation and lynching, long before Martin Luther King took up the gauntlet. (Courtesy Peace Mission.)

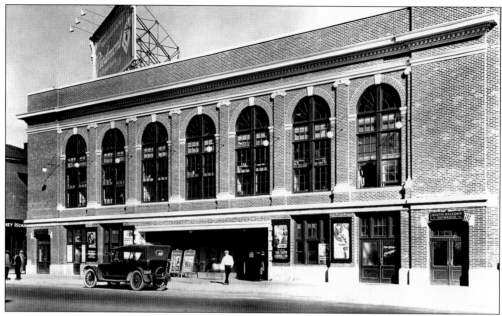

At the southeast corner of Broad and Bainbridge Streets was the Olympia Theater, shown in this 1912 photograph, which was taken at the theater's opening. Noted theater architects Hoffman and Henon designed the Olympia. In the 1930s, it was renamed the Palais Royal and was used for boxing matches and religious revivalist meetings. It is no longer standing. (Courtesy Athenaeum Glazer Collection.)

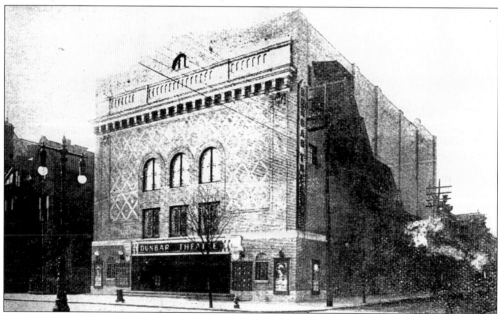

The Dunbar Theater, at Broad and Lombard Streets, opened in 1919 as a "colored," legitimate theater and had a Harlem repertory, the Lafayette Players, as its principal booking. Renamed the Lincoln Theater in 1932, it had top black stage entertainment and movies, and even some seasons of Yiddish shows in the 1940s. It was demolished to build a city health center. (Courtesy Old York Road Historical Society.)

Two

South Street to Penn Square

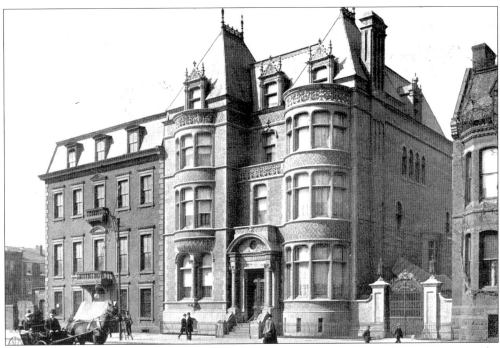

This is a 1903 view of South Broad Street's Millionaires' Row. On the left, at 512, was the mansion of Dr. J. Rhea Barton. At 510 lived Francis Sully Darley, grandson of artist Thomas Sully, and at 506, art collector John Grover Johnson. In 1900, Darley had architect Charles Burns completely renovate his house in the French Renaissance style. In 1915, when the Darley mansion came on the market, Johnson purchased it and moved next door.

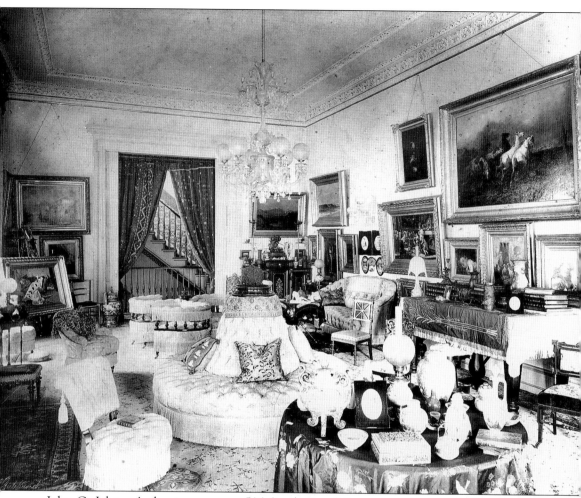

John G. Johnson's drawing room at 506 South Broad Street was photographed c. 1878 by Philadelphia photographer Frederick Gutenkunst. It is typical of an upscale Victorian drawing room of the period, the kind that Edith Wharton would have described in her 19th-century novels. In 1878, Johnson still had some wall space left to add a few new paintings to his growing art collection. However, Johnson's world-class art collection of Flemish and Italian, medieval art and 19th-century, contemporary paintings and sculpture would soon outgrow his home at 506 South Broad Street. In 1915, he moved next door to the larger Darley mansion at 510 to better display the collection. John G. Johnson's collection of art masterpieces is now on display in the Philadelphia Museum of Art. (Courtesy Philadelphia Museum of Art.)

At 507 South Broad Street stands the J. Dundas Lippincott house, which was built in 1882. Architect George T. Pearson designed the house that is sometimes mistakenly credited to architect Frank Furness. This house is the last survivor of Millionaires' Row. In 1943, Father Divine's Peace Mission purchased the house as a residence for the church's brothers, who have continued to preserve the house. (Courtesy Peace Mission.)

Built in the 1870s, 509 South Broad became the home of congressman Gen. Edward Morrell, who purchased it in 1899 for $60,000, a huge amount of money at that time. This 1914 postcard shows the house when it became the Lutheran Service House. It was one of 13 centers established by the National Lutheran War Commission for the soldiers, sailors, and marines who served during World War I.

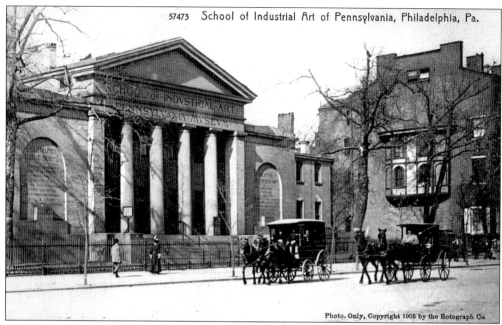

The Pennsylvania Institution for the Deaf and Dumb was on the edge of town when it was built in 1824–1826 on the northwest corner of Broad and Pine Streets. Architect John Haviland designed the school in the latest Greek Revival style. When the school moved to a new campus in 1893, it became the Philadelphia College of Art, now called the University of the Arts.

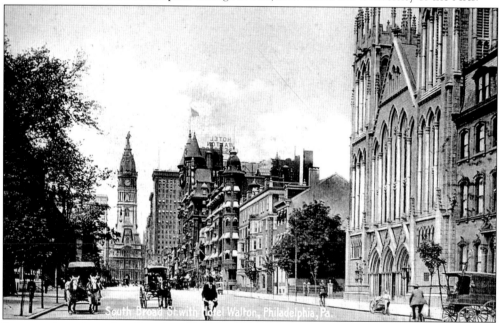

Seen on the right is the Chambers Wylie Memorial Presbyterian Church, which is located on the 300 block of South Broad Street. Dedicated in 1901, it was designed by architects Rankin and Kellogg, who won an architectural competition in 1897 with their Gothic Revival design. The church was a union of the Chambers Memorial, formerly at Broad and Sansom since 1830, and the Wylie Reformed Presbyterian Church that was on this site since 1854.

This 1914 postcard shows the Stenton Hotel, at the southeast corner of Broad and Spruce Streets. It opened in 1893 and was designed by architect Henry L. Reinhold Jr. It was the most luxurious hotel of its day and a favorite of theatrical personalities who appeared at nearby theaters. Hotel Row started here with the Stenton, then the Hotel Metropole, Hotel Walton at Locust Street, the new Ritz Carlton at Walnut Street, and on the left, the Bellevue Stratford.

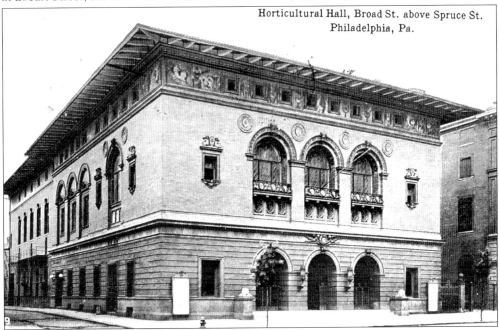

Built in 1896, Horticultural Hall was designed by architect Frank Miles Day and replaced an earlier horticultural hall that was designed by Samuel Sloan on the same site. Horticultural Hall was the magnificent meeting place for the Association of Philadelphians for the Advancement of Horticultural Interests, a group of gentlemen gardeners. The hall was torn down in 1918 to construct the Shubert Theater. The hall's elaborate marble staircases were saved and reused to create the new theater's balcony.

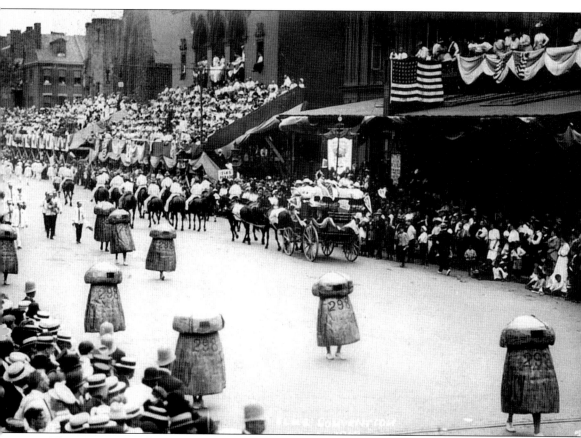

This 1907 postcard is of the Jolly Corks No. 298 (Davenport Iowa Elks Lodge) parading past the reviewing stands in front of Horticultural Hall and the people standing on the canopy of the Academy of Music. The name "Jolly Corks" was coined by an Englishman named Charles Sidney Vivian, the son of a clergyman who was a successful comic singer and dancer in the music halls of London. In November 1867, Vivian arrived in New York City to try his fortune.

With everything closed on Sunday because of New York City blue laws, a group of theatrical people began meeting for their own amusement under Vivian's leadership. A loose organization was formed to make sure they had refreshments for their gatherings. They called themselves the Jolly Corks, a name derived from a bar trick introduced by Vivian. The Jolly Corks decided that in addition to good fellowship, they needed a more enduring organization to serve those in need. On February 16, 1868, they established the Benevolent and Protective Order of Elks. (Courtesy Howard Watson Collection.)

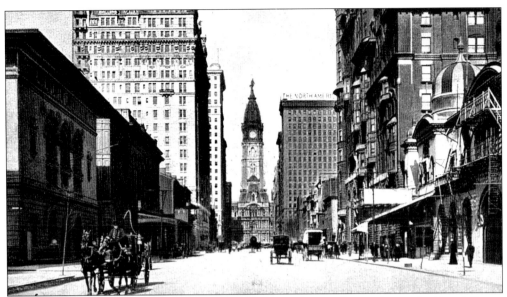

This 1905 view of Broad Street looking north from Spruce Street shows the Broad Street Theater on the right and Horticultural Hall and the Academy of Music on the left. Below is a view of the Broad Street Theater that was sandwiched between the Hotel Stenton and Metropole. Although it was built as a temporary showplace for the 1876 Centennial Exposition, it remained standing until 1937. Originally named Kiralfy's Alhambra Palace, after a Moorish palace and its designer and impresario Imre Kiralfy. When it opened, it had a restaurant and outdoor beer garden with flowers and fountains on its north side to add to the oriental-palace effect. The theater, which seated 1,400 patrons, had an illustrious career with American debuts of operas and musical comedies and, in the 1920s, guest appearances by many great stars of the silent screen.

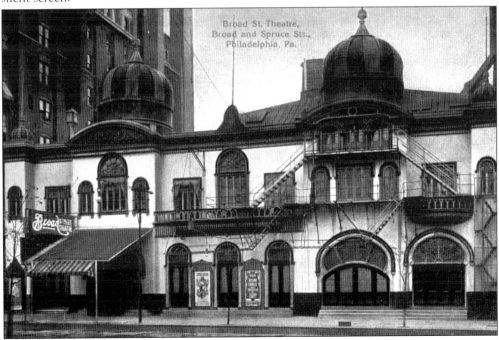

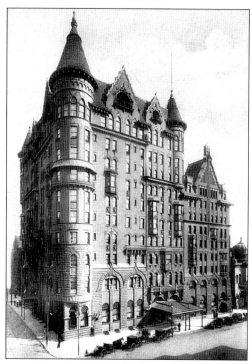

At the southeast corner of Broad and Locust was the Hotel Walton, built in 1892. The Walton was named for its owner, Robert Walton Goelet, and cost $2 million. In 1946, after going into bankruptcy, the Walton reopened as the John Bartram Hotel. The Hotel Metropole can be seen on the right. Built in 1890, both hotels were designed in a picturesque Queen Anne style by hotel architect Angus Wade. The Walton was demolished in 1966.

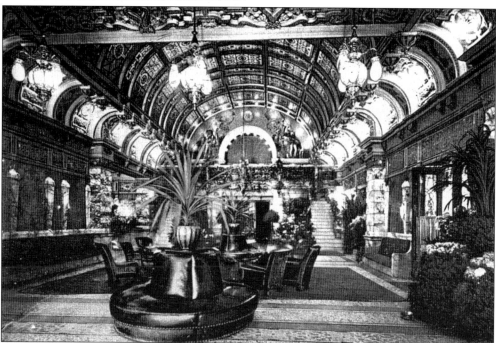

This 1909 postcard shows the luxurious lobby of the Walton, with a huge skylight and indirect electric lighting. Robert Walton Goelet was accustomed to luxury and knew what his clientele would expect. He and his brother Ogden both summered in Newport with the social elite in immense "cottages." The entrance hall to Ogden Goelet's summer cottage, Ochre Hall, was in fact larger than Robert Walton's hotel lobby.

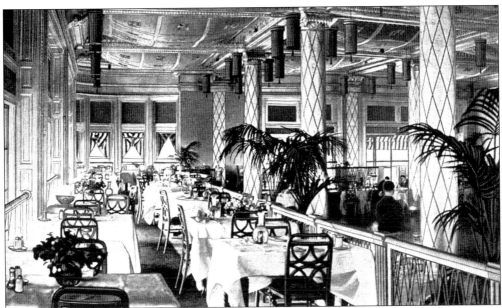

Typical of most tall late-19th-century hotels, the Hotel Walton had a roof garden. The Walton's Pierrot Roof Garden is seen above in its heyday. In the Roaring Twenties, this rooftop nightclub had a notorious reputation for wild parties and being raided by the Philadelphia police. Below is a 1905 postcard view of the elegant second-floor Palm Room, designed in a Venetian Gothic style, paneled in ornately carved dark woods and filled with tall palms for the Walton's more discreet set.

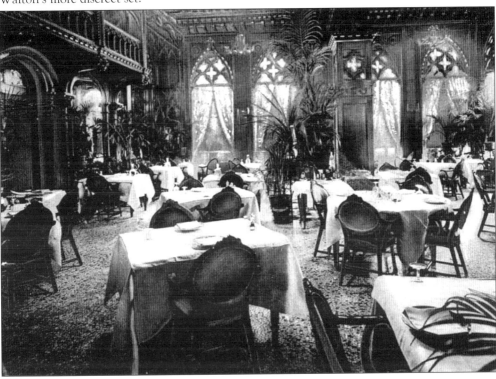

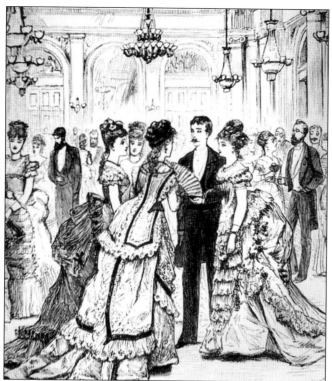

This engraving of the Outer Lobby of the Academy of Music shows it as it appeared during the opera season of 1876, glistening under gas chandeliers. The gentlemen's starched shirts and the elaborate silk and taffeta dresses of the ladies actually augmented and gave vitality to the acoustics of the academy by both absorbing and reflecting the sounds from the orchestra and the stage, an effect that acoustical engineers strive to emulate today.

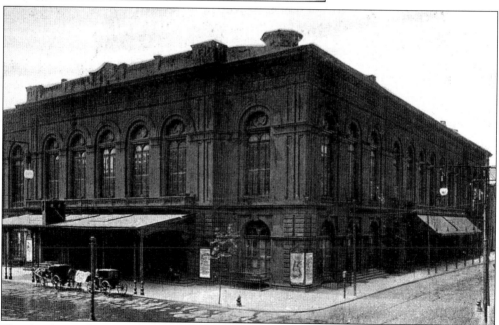

The Academy of Music opened on January 16, 1857, at Broad and Locust Streets, away from the noise of the city. Architects Napoleon LeBrun and Gustave Runge modeled the academy after the La Scala Opera House in Milan, giving it world-class acoustics. The academy was originally supposed to have a marble facade, but the money was spent instead on the elaborate interior. It was the home of the Philadelphia Orchestra.

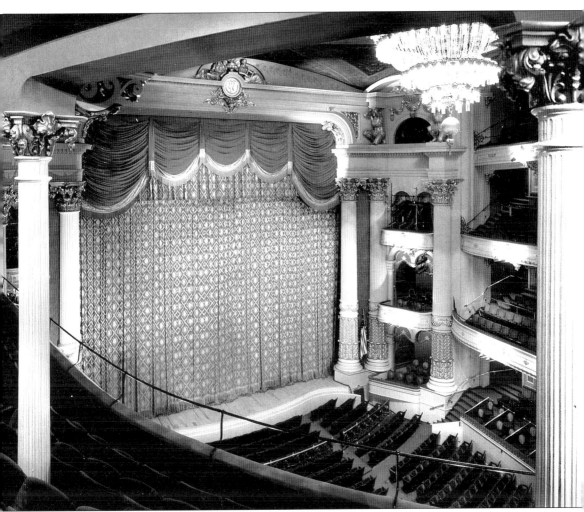

In 1872, the Republican National Convention nominating Ulysses S. Grant for president was held in the Academy of Music's auditorium. Recently, the magnificent auditorium has been carefully restored to look as it did when General Grant visited the building. The auditorium has magnificent acoustics; its secret is the great, bowl-shaped well in the subbasement, directly under the ornate dome of the auditorium. The chandelier seen above was designed and built specially in 1857 by the Cornelius Company of Philadelphia for this space. Chief restoration architect Hyman Myers was careful not to tamper with the room's great acoustical quality when planning the academy's restoration. (Courtesy VITTETA; photograph by Joanne Bening.)

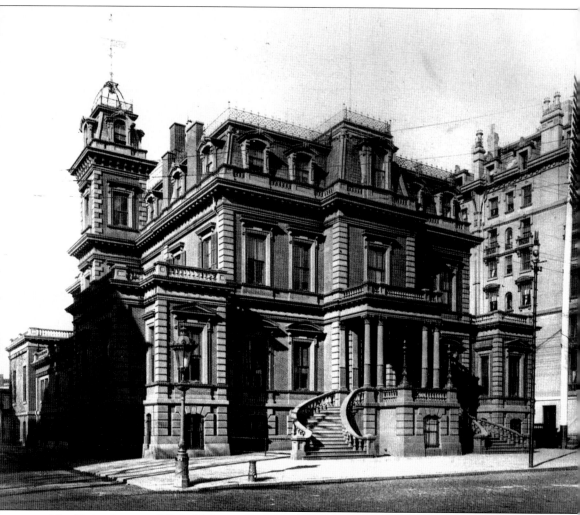

The Union League of Philadelphia, at Broad and Sansom Streets, was founded on December 27, 1862, as a patriotic social society whose purpose was to support Pres. Abraham Lincoln and uphold the Constitution of the United States during the Civil War. On May 11, 1865, the Broad Street clubhouse opened. Designed by architect John Fraser and built by contractor John Crump, the Union League is an elegant brownstone, Second Empire–style mansion with a great entrance staircase and balconies to review the parades. The Union League was not just a social club; by the end of the Civil War, its several thousand members had raised and equipped nine regiments and two battalions and vigorously supported President Lincoln and the war effort. Gen. Ulysses S. Grant was given a reception at the Union League one month after it opened, on the day the Philadelphia troops returned to the city. (Courtesy Union League of Philadelphia.)

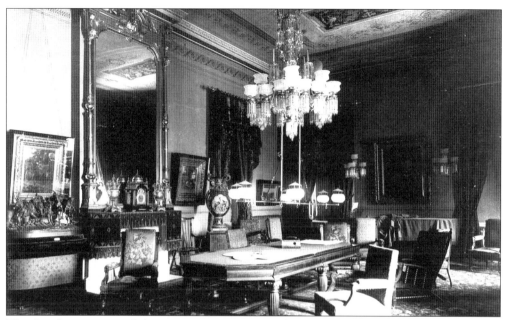

The lavish interiors of the Union League were designed by George Herzog, a German immigrant who studied at the court of Ludwig I. Herzog. Ludwig I. Herzog was a Union League member who was considered to be one of the foremost interior decorators of the 19th century. He was an expert in historical and allegorical subjects and an artist of the first caliber. Herzog also designed rooms in the Masonic Temple and the Supreme Court and mayor's offices in Philadelphia City Hall. Above is the Union League's parlor, and below is the league's library, both as they appeared in the mid-1880s with gas chandeliers. Note the strategically located brass spittoons on the floor, a common fixture for a men's club in the 19th century. (Courtesy Union League of Philadelphia.)

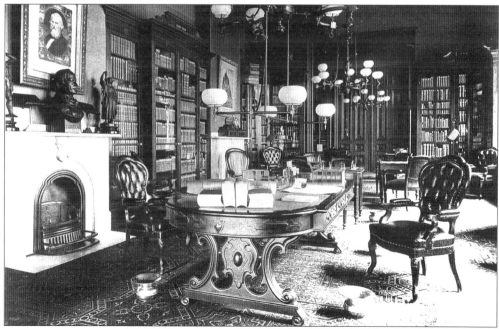

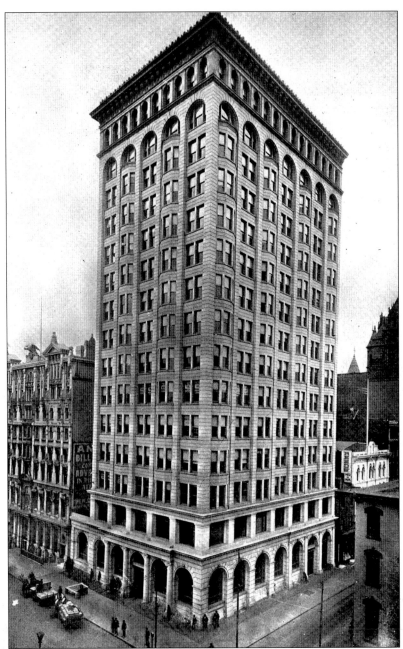

The Land Title Bank and Trust is the oldest title insurance company in the world. The Land Title Building, at the southwest corner of Broad and Chestnut Streets, was Philadelphia's first real skyscraper to be built with an all-steel structural frame. Erected in 1897, the office tower was designed by architect D.H. Burnham & Company of Chicago, who later designed the Wanamaker Department Store. Burnham's Chicago architectural style of large glass bay windows brought natural light into the offices at a time when electric lighting was still in its infancy. Burnham indulged himself by putting his daughter Margaret's face on the cherubs that are at the top of the cornice. In this 1898 view, the Lafayette Hotel (originally the La Pierre) is seen on the left. It was soon to be demolished for construction of the second Land Title tower.

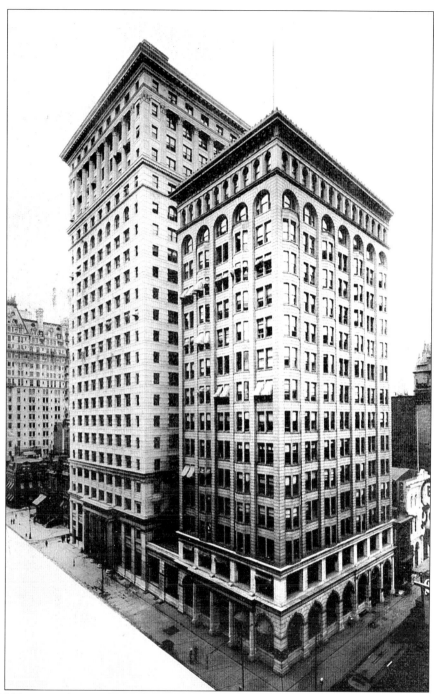

This 1909 postcard view shows the two towers of the Land Title Building. The southern, 22-story addition was built in 1902 and was also designed by architects D.H. Burnham & Company. The new tower is more classical in its detail than the earlier tower with giant columns on the upper floors that reflect the American Renaissance style made popular by Burnham at the 1893 Columbian Exposition in Chicago. Both buildings are standing today on South Broad Street between Chestnut and Sansom Streets.

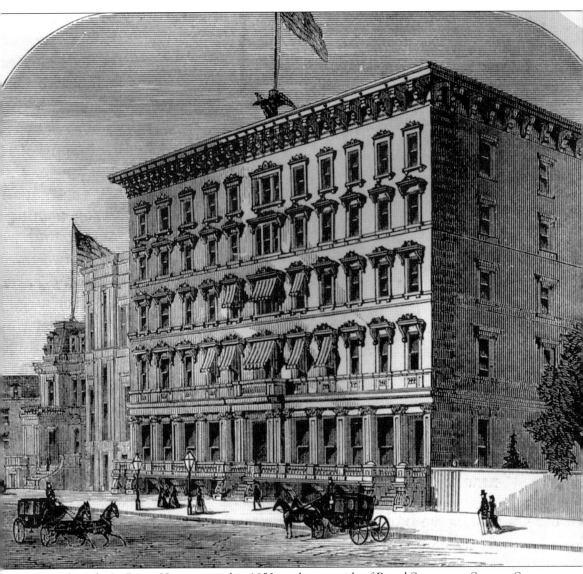

When the La Pierre House opened in 1853 on the west side of Broad Street near Sansom Street, it was touted to be America's most luxurious hotel. In the late 1860s, the railroad tracks that carried horse-drawn freight and passenger cars was removed from South Broad Street, making it a more desirable address. The La Pierre was designed by architect John McArthur Jr., who later designed Philadelphia City Hall. A huge sculpture of an American eagle sat on the building's cornice overlooking the cobblestones of Broad Street. This engraving from an 1876 Centennial Exposition guidebook also shows the Academy of Sciences on the left of the hotel and the Union League flying the American flag. In 1880, the La Pierre merged with the Hotel Lafayette that was torn down c. 1897 for the construction of the first Land Title Building tower. The old La Pierre House was itself demolished in 1900 for the construction of the second Land Title tower.

This "Philadelphia after Midnight" postcard of the Bellevue Stratford Hotel was part of a set of 12 published in 1907, just in time for the Elks convention in Philadelphia. They give a vaudeville comic's impression of Philadelphia after having a few drinks. At that time, Philadelphia had the reputation of being the staid "Quaker City" where the sidewalks were rolled up at night.

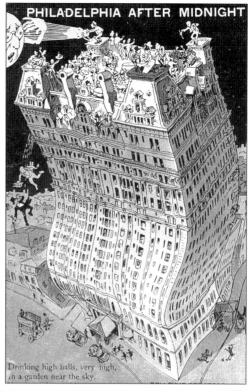

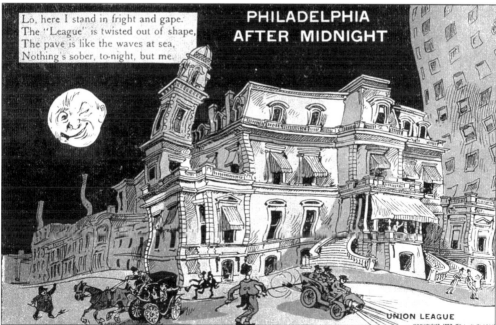

This "Philadelphia after Midnight" postcard of the Union League twisted out of shape portrays a wild, party-loving city inhabited by serious alcoholics. This contradiction to reality probably made these postcards even more humorous to the Elks conventioneers, since Philadelphia completely closed down around them on Sunday because of its strictly enforced blue laws.

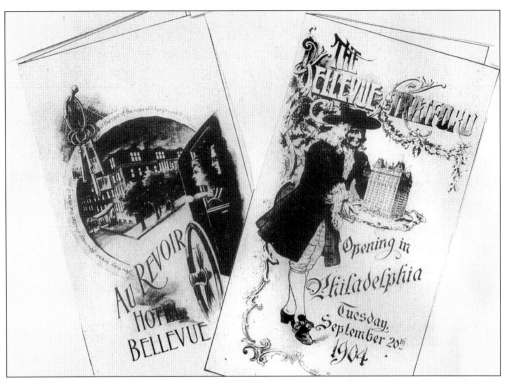

Shown together are the last menu of the old Hotel Bellevue on the evening of September 19, 1904, and the first menu of the new Bellevue Stratford Hotel at its opening on September 20, 1904, at 12:01 a.m. Below is a 1900 postcard that shows the old Stratford Hotel (left), on the southwest corner of Broad and Walnut Streets, and the old Bellevue Hotel, on the northwest corner. The old Bellevue was torn down to build the new 987-room Bellevue Stratford Hotel. On Tuesday, September 20, 1904, a famous last-evening party was held in the Stratford Hotel; food and drinks were on the house. At midnight, the guests crossed the street to continue the celebration at the new Bellevue Stratford, a memorable evening in Philadelphia's social history.

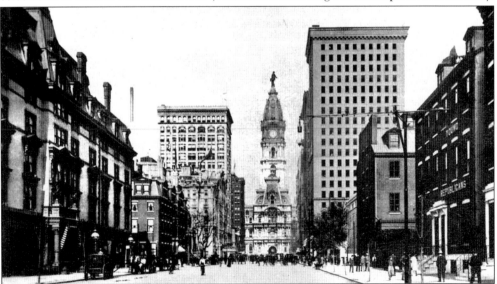

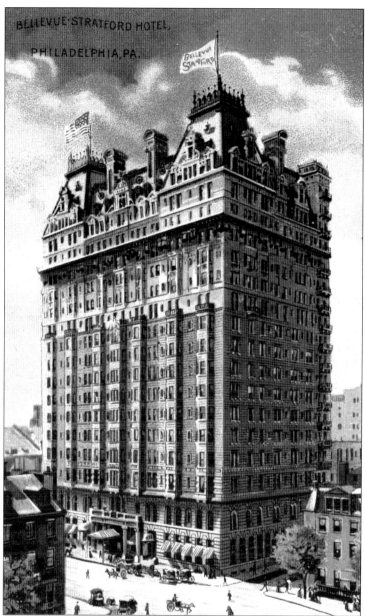

The Bellevue Stratford Hotel was proprietor George Boldt's masterpiece. From humble beginnings as a kitchen boy in New York and with lots of perseverance, Boldt became the proprietor of the Waldorf Astoria Hotel in New York City and went on to make another fortune in the life-preserver business. In 1902, Boldt hired Hewitt Brothers Architects to design his hotel in the French Renaissance style. Thomas Edison designed special lighting for the ballroom. No expense was spared on the hotel's construction. When completed, the hotel had 987 rooms that were serviced by a staff of 800. Philadelphians had never seen such luxury on such a grand scale. In 1913, the Bellevue Stratford was expanded with a tall addition on its west side. It continued to be one of Philadelphia's premier meeting places until the summer of 1976, when a bacterium (*Legionella*) closed the hotel for good. However, the building survived and was fully restored in 1980, and again in 1989, and it now serves as a hotel and office building.

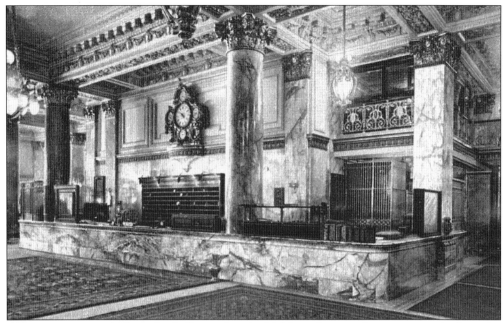

These 1904 postcards show the Bellevue Stratford lobby—the most luxurious ever built in the United States at that time. People came merely to look upon the golden marble of the lobby desk, seen above, and the ornate elevators, elevators being considered a novelty at that time. The hotel's owner, George Boldt, loved Shakespeare and had a statue of the bard, flanked by tall screens, placed in the lobby corridor, as seen in the view below. Boldt added "Stratford" to the hotel's name in honor of Shakespeare's hometown, Stratford-on-Avon.

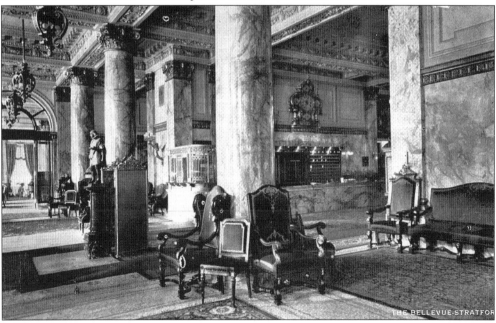

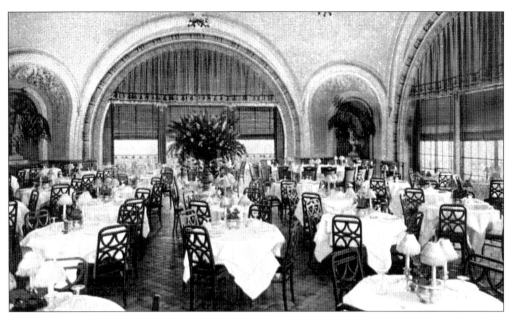

The Bellevue Stratford Hotel functioned as a sort of clubhouse for Philadelphia's elite. The South Garden Room was the place to be seen. The Hunt Room was the meeting place for city politicians and movers and shakers to lunch and make deals. The ladies had their own Ladies' Dining Room. The hotel immediately became a center of the city's social life, playing host to balls, parties, weddings, and charity functions.

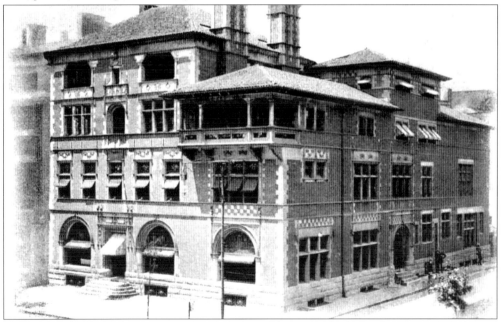

Next to the Bellevue Stratford Hotel at the corner of Broad and Chancellor Streets was the Art Club. In 1887, architect Frank Miles Day won the competition for the Art Club's design after just returning from Europe with his famous sketchbook full of historical details. Day's unique Venetian design for the club caused a sensation in Philadelphia art circles. Unfortunately, it was demolished for a parking lot in 1975.

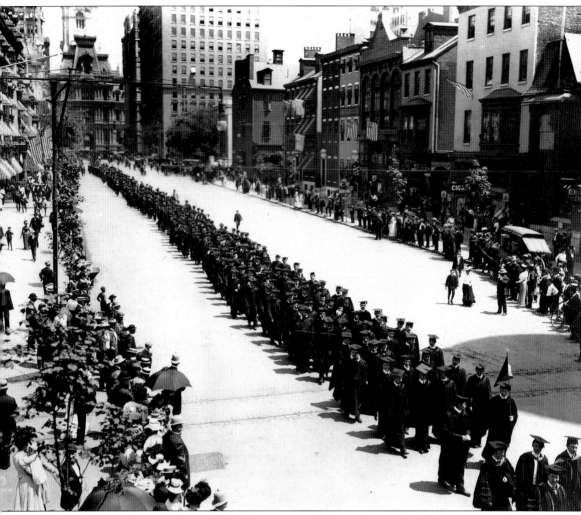

The 1901 graduating class of the University of Pennsylvania had their commencement exercises at the Academy of Music. They marched in procession from College Hall on Penn's West Philadelphia campus at Thirty-fourth and Walnut Streets to the academy. South Broad Street had been recently paved with asphalt, and its width made it a favored parade route. On the left is the old Stratford Hotel. The Young Republicans clubhouse and many private residences, such as the Dundas-Lippincott Mansion at Broad and Walnut, can still be seen on the east side of the street. (Courtesy University of Pennsylvania Archives.)

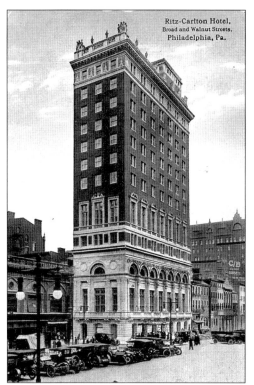 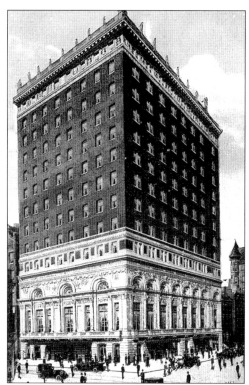

Two families of great wealth and power were united when the daughter of William Lukens Elkins, Eleanor, married George D. Widener, son of P.A.B. Widener, in 1883. The story goes that Mrs. George Widener was asked to leave the Bellevue Stratford Hotel during a cotillion ball because she lit a cigarette. The next day, her husband, George, marched into George C. Boldt's office and informed him he was going to build a more luxurious hotel across the street where the patrons may smoke. In 1911, Widener hired Horace Trumbauer to design the new Ritz Carlton Hotel at the southeast corner of Broad and Walnut Streets. Originally, the hotel was built only one bay wide. In 1913, it was enlarged to three bays due to its success. Tragically, in 1912, on a family trip to Europe to buy his daughter Eleanor's wedding trousseau and hire a French chef for the new hotel, George and his son Harry were lost in the *Titanic* disaster. The chef missed the boat and survived.

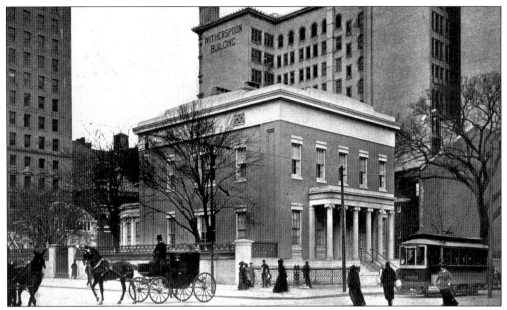

This 1900 postcard view is of the Walnut Street entrance to the Dundas-Lippincott Mansion that sat on the northeast corner of Broad and Walnut Streets. The house was commonly called the "Yellow Mansion" and was built in 1839 by James Dundas, a banker. A famous elm tree seen on the right was full grown in 1818. The mansion was demolished in 1902, and the Forrest Theater was later built on the site.

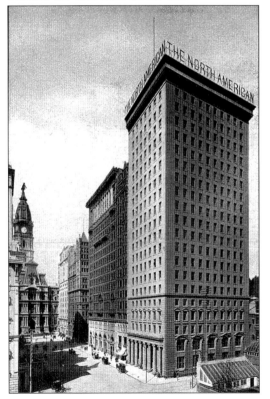

The North American Building still stands at the northwest corner of Broad and Chestnut Streets. It was designed by architect John H. Windrim in 1899 for Thomas B. Wanamaker, publisher of the *North American* newspaper. Its uncluttered facade is a sharp contrast to the picturesque designs of tall buildings on Broad Street built a few years earlier. The greenhouses of the Dundas-Lippincott Mansion can be seen in the foreground.

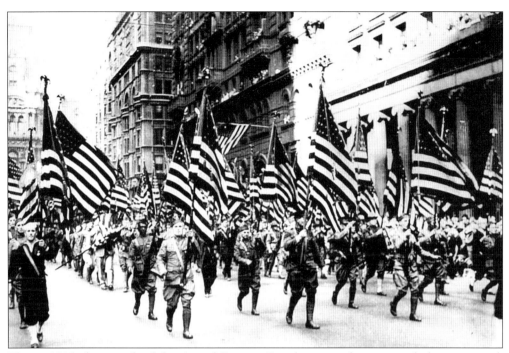

This c. 1918 photograph of the Armed Services Parade was made into a real photo postcard. The troops are marching south between Chestnut and Sansom Streets, in front of the North American Building. Because of its width and length, Broad Street, south and north, has been a favored parade route since 1876.

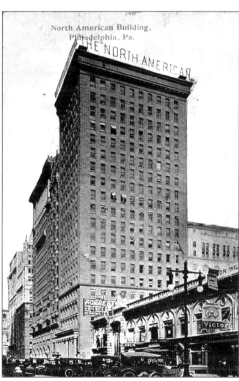

Pictured in a 1915 postcard is the Forrest Theater, at Broad and Sansom Streets, in the same year that the theater began to show moving pictures. It opened with *Birth of a Nation*. The Forrest was built in 1907 on the site of the old Dundas-Lippincott Mansion. Designed by architects Marshall and Fox, it seated 1,820 people. Unfortunately, the Forrest had a short life span, as did so many of Philadelphia's great theaters. It was demolished in 1927 to build the Fidelity Bank Building.

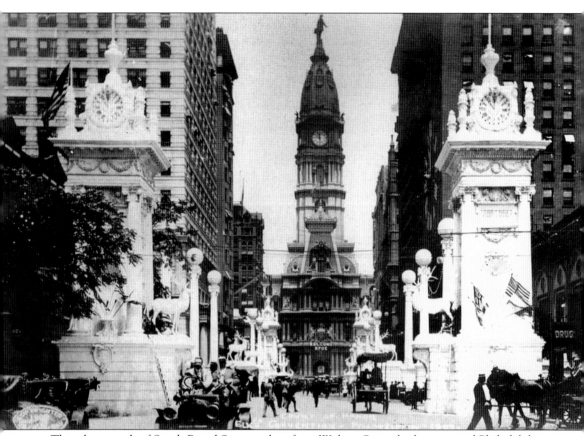

This photograph of South Broad Street, taken from Walnut Street looking toward Philadelphia City Hall, was made in 1907, when the Philadelphia Elks Lodge No. 2 hosted the Benevolent and Protective Order of Elks Convention. The sign on city hall says, "Welcome B.P.O.E." Not since the court of honor decorations made for 1898 Peace Jubilee had the city gone to such expense to decorate Broad Street. Broad Street, south and north, was decorated with great plaster pylons and elk statues made by talented Italian sculptors and plaster workers. Market Street also had elk statues and decorations on every block. The Elks greeted each other with the cheerful salutation "Hello, Bill," which had begun in 1897 at the Elks National Reunion in Minneapolis. When the Elks left, all these elaborate decorations were just thrown away. The Elks convention was memorialized in the hundreds of "Hello, Bill," and "Welcome B.P.O.E" postcard designs and real photo postcards of the Elks parading down Broad Street that were published in 1907 to commemorate the event.

Broad Street at night, looking south from Chestnut Street, glittered in 1915, with the electric lights of newly built hotels, skyscrapers, and theaters. It was truly the "Avenue of the Arts." In the foreground at Chestnut Street is the classical Girard Trust Bank, which was built of white marble in the Neoclassical Revival style; it was one of the great banking spaces in Philadelphia.

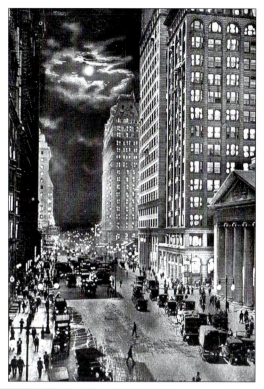

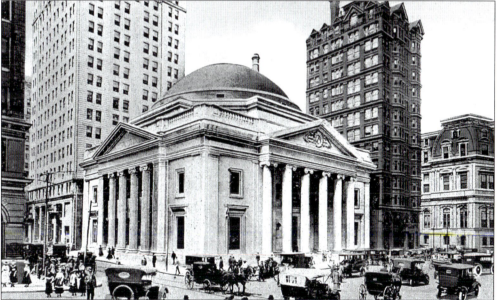

The white-marble Girard Trust Bank, at the northwest corner of Broad and Chestnut Streets, stands out from its high-rise neighbors. Designed by the architectural firm of McKim, Mead, and White, and Furness and Evans, it was completed in 1908. Its tile dome is an engineering masterpiece based on the Roman Pantheon. Visible on South Penn Square is the dark brick West End Trust Building designed in 1898 by Furness and Hewitt. It was replaced with a new tower in 1930.

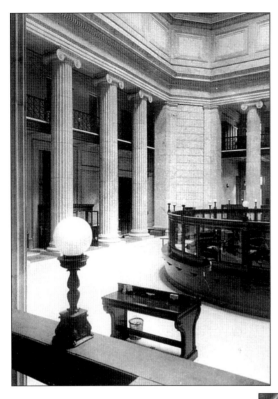

This 1908 photograph of the Girard Trust Bank's great banking room was made by the architects and presented to Effingham Buckley Morris, president of the bank. It was Morris's vision that guided the designers to build this great classical marble building as a statement of the bank's stability. The circular teller's counter follows the shape of the dome above and is surrounded by two-story Greek Ionic marble columns. (Courtesy Hillier and Arden Group.)

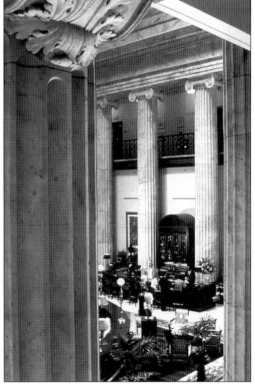

In 2000, the great banking room became the entrance lobby to the new Ritz Carlton Hotel. The building was carefully restored to its former glory by the Hillier Group under the supervision of head restoration architect James Garrison. It is a fine example of adaptive use with the tellers' area shown previously now being used as the hotel's elegant Rotunda Lounge. (Courtesy Hillier and Arden Group; photograph by Tom Crane.)

Three
PENN SQUARE

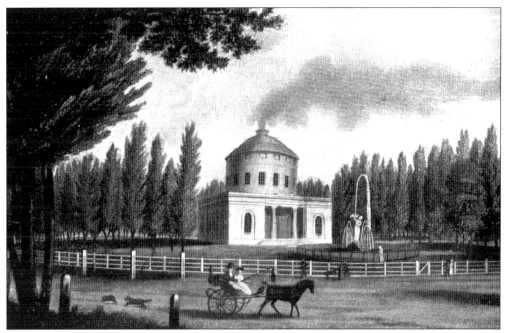

Where Broad Street and Market Street intersect was Philadelphia's largest open square, Centre Square, later renamed Penn Square. It was originally a fenced-in park. In 1799, engineer Benjamin Latrobe designed this white-marble temple, which was a steam engine pump house for Philadelphia's water system. However, the pump house proved too small for the massive machinery needed for a growing city, and by 1829, a new waterworks was built at Fairmount. The pump house was demolished, and Market and Broad Streets were allowed to cut through the square, breaking it into four parts.

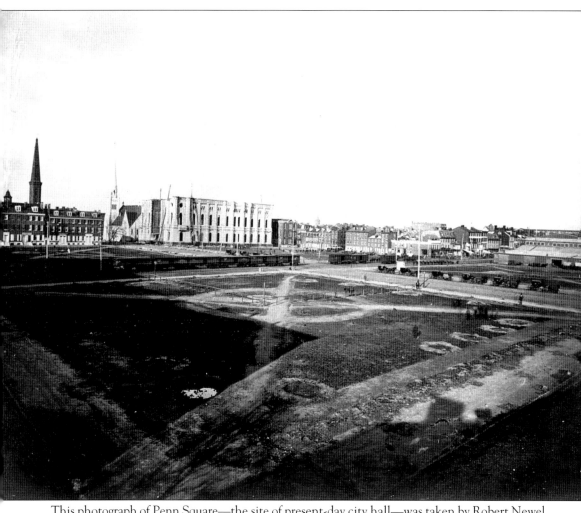

This photograph of Penn Square—the site of present-day city hall—was taken by Robert Newel in the 1868, from the southwest corner of South Penn Square. It shows Penn Square after it had been cleared in preparation for the construction of city hall. Broad Street is shown crossing the square, and the old Pennsylvania Railroad freight depot, where the John Wanamaker Building now stands, can be seen to the east of Juniper Street. Along Market Street is the line of horse-drawn freight cars. (Steam engines were not permitted in downtown Philadelphia at that time.) The prominent and roofless building at the upper center is the new Masonic Temple, which was under construction at Broad and Filbert Streets. To the right of the temple is La Salle College at Juniper and Filbert Streets. The Arch Street Methodist Episcopal Church, next to the Masonic Temple, and the dark tower of the First Baptist Church can be seen in the distance. (Courtesy Masonic Library and Museum of Pennsylvania.)

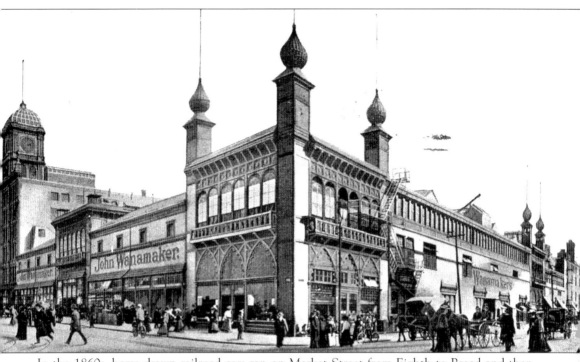

In the 1860s, horse-drawn railroad cars ran on Market Street from Eighth to Broad and then north on Broad Street to Willow Street, west to Fairmount, and over across the Schuylkill River. The Pennsylvania Railroad had its freight depot at Thirteenth and Market Streets. Enterprising John Wanamaker gambled that the construction of Philadelphia City Hall and the imminent removal of the railroad tracks on Market and Broad Streets would shift the center of commerce west to Broad Street. Since 1861, Wanamaker had been selling ready-made clothing at Sixth and Markets Streets. He opened his new department store, one of the first in the country, in 1876, on the old depot site and named it the Grand Depot. It looked like an exotic oriental bazaar to entice the Centennial Exposition crowds. On Christmas Day in 1878, it became the first store in America with electric lighting. John Wanamaker was right; his "New kind of Store," as seen from city hall in this 1900 postcard, was a great success, second in popularity only to Independence Hall as a Philadelphia attraction.

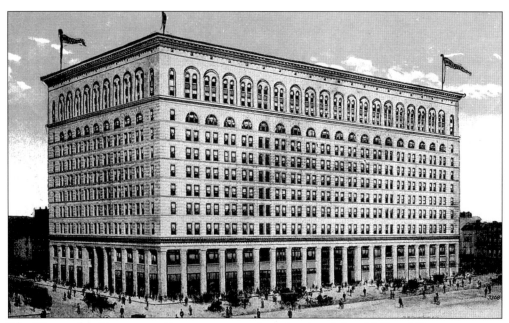

The Wanamaker Department Store, constructed on the site of the old Grand Depot store, was built in three phases from 1901 to 1911. Architect Daniel H. Burnham, who also designed Chicago's Marshall Fields store, designed a five-story central court in the middle of the building with the selling spaces arranged around it. The elegant exterior is like an exaggerated version of a granite and limestone Italian Renaissance palazzo.

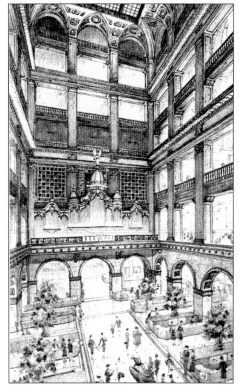

To adorn his Grand Court, seen in this sketch, John Wanamaker purchased the second largest organ in the world and a great bronze eagle from the 1904 Louisiana Purchase Exposition. "Meet me at the eagle" became a favorite saying for friends looking for a meeting place. The Grand Court stages an immense light and water display that is accompanied by a great organ every Christmas season. The display has become a Philadelphia tradition.

The Betz Building, designed by Will H. Decker and built in 1890 at Broad and South Penn Square, was one of Philadelphia's first high skyscrapers built with interior steel-frame construction. Decker designed the building like a wedding cake with lots of horizontal cornices to visually cut down its 13-story height. In this early-1890s photograph, the Betz Building towers over its Broad Street neighbor, the Girard Life Insurance Company Building, by five floors.

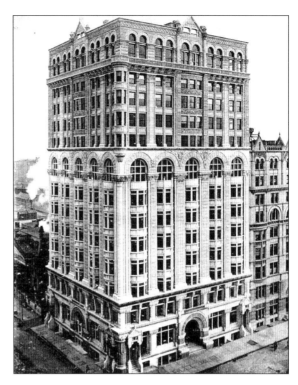

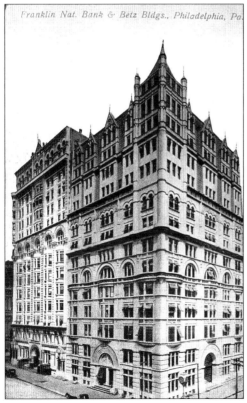

The Girard Life Insurance Annuity Trust Company, at the northeast corner of Broad and Chestnut Streets, was built in 1888–1889 and designed by noted architect Addison Hutton. Six years later, Hutton was asked to add a tower and five additional floors, making the building higher than Decker's Betz Building. Both architects were obviously at a loss when it came to designing skyscrapers, as they were still designing in a picturesque Victorian style.

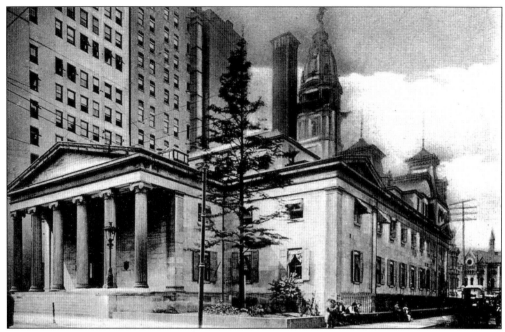

Located on South Penn Square and Juniper Street was the second U.S. Mint Building, which was built in 1829 by architect William Strickland in a classical style. Strickland also designed the Philadelphia Naval Home. This 1900 view looking north shows the Chestnut Street facade that was identical to the one facing Penn Square. In the background is the tower of city hall. In 1902, the second U.S. Mint Building was demolished to make way for the Widener Building.

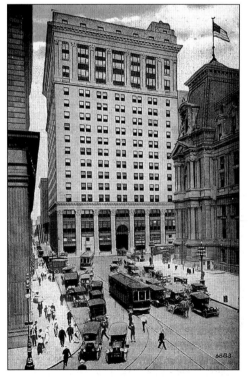

The Widener Building, on South Penn Square, was built in 1915 and designed by architect Horace Trumbauer, who designed all of Widener's architectural projects. He designed a unique ground-floor arcade that ran from Chestnut Street to Penn Square. Since 1916, the arcade was home to J.E. Caldwell jewelers, which closed in 2003. Trumbauer matched the Widener Building's facade and cornice lines with those of the adjacent Wanamaker Building, thereby unifying this corner of Penn Square.

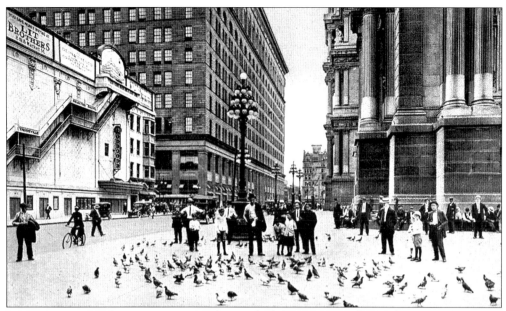

In 1917, East Penn Square was a great place to feed the pigeons. Afterwards, one could walk to the Globe Theater, which opened in 1914 at Juniper and Market Streets, and see a vaudeville show and a full-length motion picture. The Globe was demolished in 1930. In this view, Wanamaker's department store can be seen across Market Street, and the site of the old U.S. Mint on Juniper Street is still an empty lot.

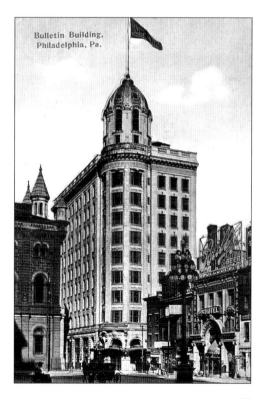

Diagonally across from Philadelphia City Hall at Juniper and Filbert Streets was the Bulletin Building, home of the *Evening Bulletin* newspaper. Built in 1908 on the former site of La Salle College's second home, it was designed by architect Edgar V. Seeler, who accented the corner with a domed round tower, a stylistic cliché of the period. The building with the rooftop "BALTZ" beer sign was the popular Harry Edwards Bar-Café.

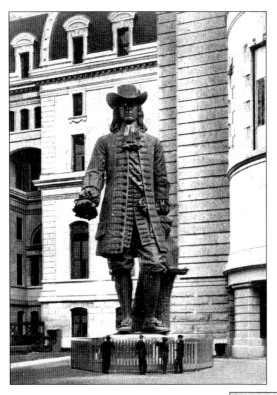

The statue of William Penn stood 37 feet high in the city hall courtyard for Philadelphians to admire until it was raised to the tower in 1894. The statue was the creation of sculptor Alexander Milne Calder, father of the designer of Logan Circle's Swan fountain (Alexander Stirling Calder) and grandfather of the inventor of the modern mobile (Alexander "Sandy" Calder). Calder labored for 20 years, turning out plaster models to be executed in granite by an army of skilled craftsman.

At one time the largest structure in the United States and the tallest building in the world, Philadelphia City Hall covers all five acres of Centre Square. Chief architect John McArthur Jr. started the project in 1871 in association with architect Thomas U. Walters. The Second Empire–style building was completed in 1901. Its exterior is festooned with symbolic sculpture; its elegant public rooms were designed by famous interior designer George Herzog.

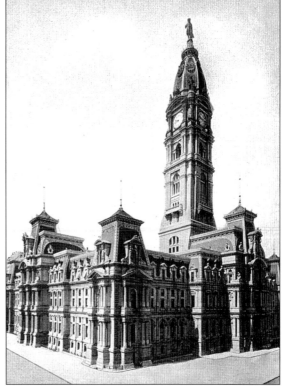

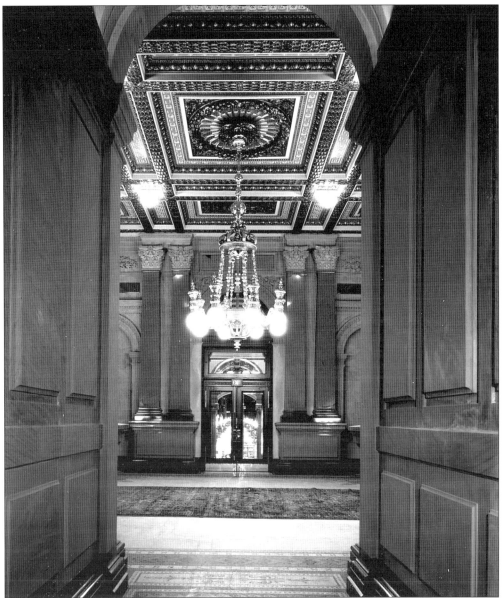

In the 1950s, someone at city hall came up with the idea of turning Conversation Hall, one of city hall's great public rooms, into offices. A second floor was inserted into the space, and it was compartmentalized into small offices. Fortunately, the architect for the project, George I. Lovatt Jr., an unsung hero to whom Philadelphians owe a great debt, had the foresight to design the renovation with the least amount of intrusion on the original fabric of the room. He even encased the great chandelier, seen above, where it hung to protect it and keep it from being stolen or lost, with the idea that the room would be restored someday. In 1982, George I. Lovatt Jr.'s vision came true and Conversation Hall was restored to its former glory by chief restoration architect Hyman Myers. To the restoration team's surprise and delight, when they removed the temporary office walls, there was the chandelier intact, the original, elaborate George Herzog–designed ceiling, and the marble walls unscathed. (Courtesy VITTETA; photograph by Tom Crane.)

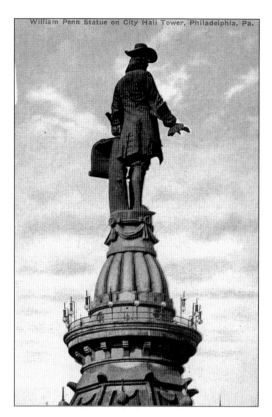

William Penn's statue sits atop a 547-foot tower. A gentlemen's agreement not to build higher than Penn's hat kept city hall Philadelphia's tallest building. When Mayor Wilson Goode was approached by developer Willard Rouse to build the towering 960-foot-tall Liberty Place, Goode informed him of the unbroken gentlemen's agreement. According to Goode, Rouse replied, "I ain't a gentlemen." Philadelphia's unique skyline, once dominated by the city hall tower, was forever changed.

This 1908 postcard view looks north toward Philadelphia City Hall. On the left is the Pennsylvania Railroad station, and in the foreground is the dark brick West End Building. William Penn atop city hall's clock tower dominated the skyline then. Centered on Broad Street, it could be seen from both North and South Broad Street and was visible for miles on clear days as a Philadelphia landmark.

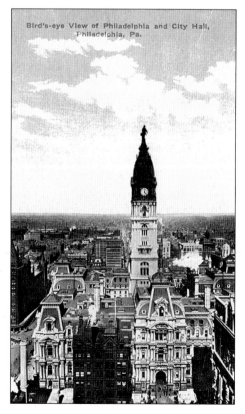

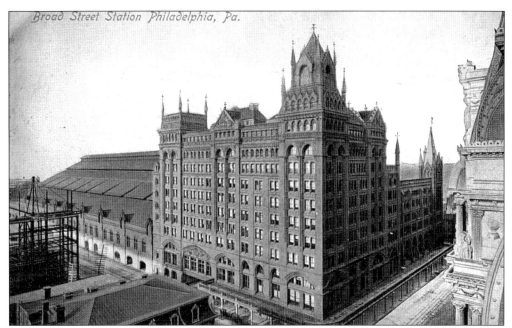

The Pennsylvania Railroad Broad Street Station, once the largest passenger train station in the world, was designed by Wilson Brothers & Company in 1881–1882 and added to in 1892–1893 by Furness, Evans, & Company. Trains approached on the famous "Chinese Wall" and arrived under a 300-foot-wide, three-hinged, wrought-iron-roofed train shed. The great train shed, seen below, burned down in 1923, and in 1933, the Pennsylvania Railroad decided to pull out of Center City and build a new station at Thirtieth Street. The massive terra-cotta and granite station was torn down in 1953 to make way for Penn Center. Sculptor Karl Bitter's bas-relief *Spirit of Transportation*, originally in the old Broad Street Station, was moved to the Thirtieth Street Station and can be seen there today.

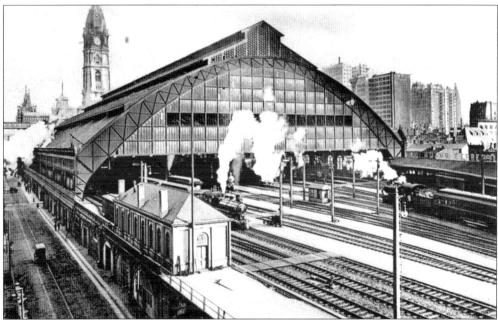

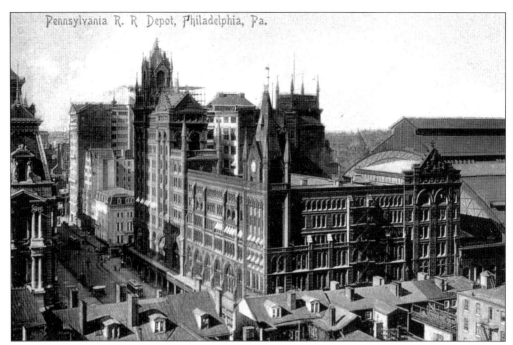

The west side of Penn Square is shown in 1902 before it became developed with large skyscrapers. The Pennsylvania Railroad station dominates the view. In the foreground are the roofs of mid-19th-century row houses that once lined Filbert Street.

In this 1915 postcard, one can see the rapid changes that occurred to West Penn Square in only a few years. The domed tower building is a 1913 addition to the Arcade Building, which was built in 1903. The classical-style Third National Bank, built in 1911 and designed by architects Baker and Dallet, is at the southwest corner of Market Street and West Penn Square.

Four

NORTH BROAD STREET: PENN SQUARE TO MASTER STREET

Bird's Eye View, North from City Hall, Philadelphia, Pa.

This 1910 postcard view shows straight-as-an-arrow North Broad Street from the Philadelphia City Hall tower. North Broad Street became a favorite place for fraternal organizations to build their headquarters and for a growing automobile industry to locate their showrooms. The dark band of industrial buildings west of Broad and Callowhill Streets indicates the Baldwin Locomotive Works and the area where the Reading train tracks cross under Broad Street. In the right foreground are the steeples of the Masonic Temple and Arch Street Methodist Episcopal Church; on the left is the United Gas Improvement Company.

In the 1902 postcard above, the skyscrapers are just beginning to be built on North Broad Street. In the foreground is the statue of Civil War general Fulton Reynolds pointing to the Masonic Temple. The shabby hotel in front of the statue is a remnant of a once elegant block of houses built in the 1860s along Filbert Street. With the construction of Penn Station, the houses were converted into shops, restaurants, and hotels. Below is the United Gas Improvement Building, which was designed in 1898 by the Wilson Brothers. Three doors west is the new central YMCA, built in 1908 and designed by Horace Trumbauer. In 1915, the 1400 block of Filbert Street was torn down to build Reyburn Plaza.

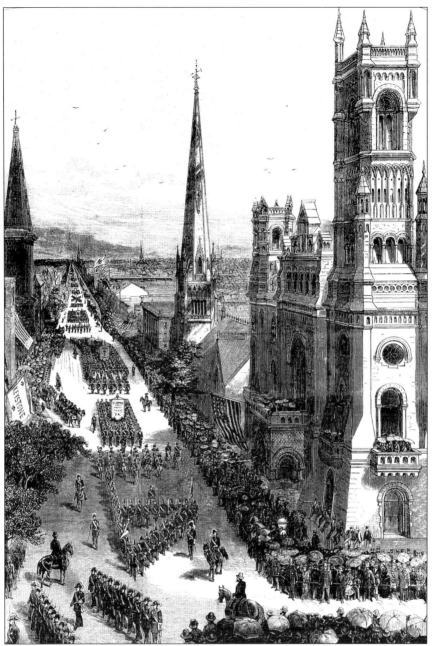

Passing in review in front of the Masonic Temple on North Broad Street is the Grand Commandery of the U.S. Knights Templars, who came to Philadelphia to visit the 1876 Centennial Exposition. The area north of city hall was a catalog of architectural styles. Next to the Masonic Temple is the Arch Street Methodist Episcopal Church, built in 1869 and designed by Addison Hutton. The dark English Gothic tower of the First Baptist Church, designed by Stephen Button, stood at the northwest corner of Broad and Arch Streets. The unfinished tower of the Lutheran Church of the Holy Communion—built in 1875, designed by Frank Furness, and located at the southwest corner—is also visible in this illustration from the 1876 *Illustrated History of the Centennial Exposition*.

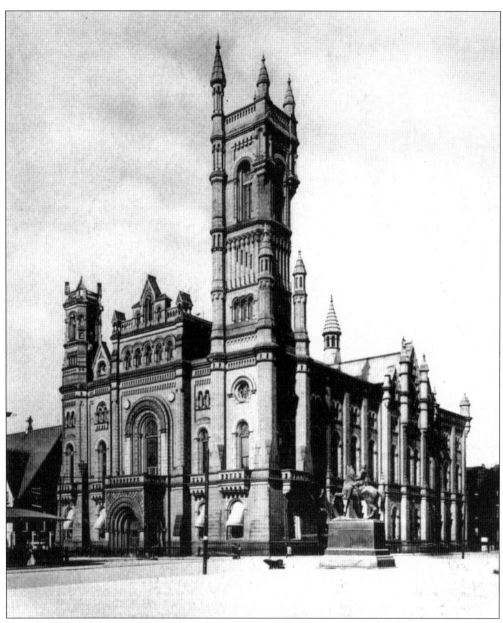

Not all of Philadelphia's Masons were happy when a shabby block north of Market Street that had small depots selling coal and lumber with train tracks running in front was chosen for the site of the new Masonic Temple. A competition was held and young James Windrim, a brother freemason, was the winner with his picturesque Norman design. The cornerstone was laid in 1868; it took fives years to build the temple with huge precut granite blocks, many weighing five tons, brought by horse-drawn freight cars from Glenwood Avenue. The temple exterior was dedicated in September 1873 after spending $1.6 million, an immense sum of money equivalent to hundreds of millions today. It took the Masons 14 more years to pay off the debt and raise enough money to start the interiors, which were exquisitely designed from 1889 to 1904 by leading 19th-century interior designer George Herzog. In 1902, the Masonic Temple was one of the first fully electrified buildings in Philadelphia.

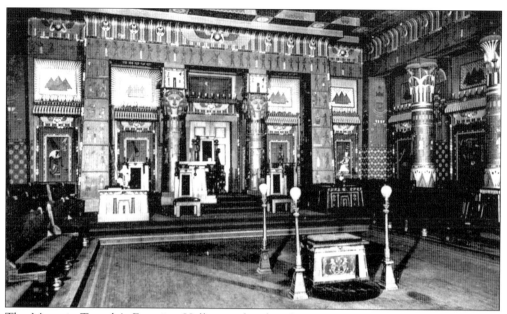

The Masonic Temple's Egyptian Hall, completed in January 1889, was one of the first halls completed in the building. Designed by noted decorative artist Herman Herzog, it is among the finest rooms in Philadelphia. Herzog used authentic Egyptian details in the room's architecture, decoration, and furniture, some of which is made from solid ebony. It is one of seven lodge rooms, each designed in a different period style.

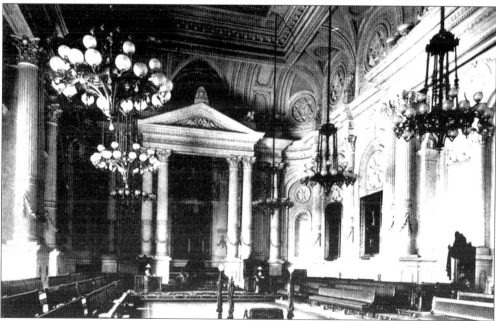

In 1904, George Herzog designed Corinthian Hall, the largest of the lodge halls, in a Grecian classical style. Herzog also designed Ionic Hall, Egyptian Hall, Norman Hall, Oriental Hall, Renaissance Hall, and Gothic Hall, and the Grand Banquet Hall and Library. None of the seven lodge halls has a religious function. Although they seem perfect in design and execution, the Masons purposely left one imperfection in each room's design to signify man's imperfection.

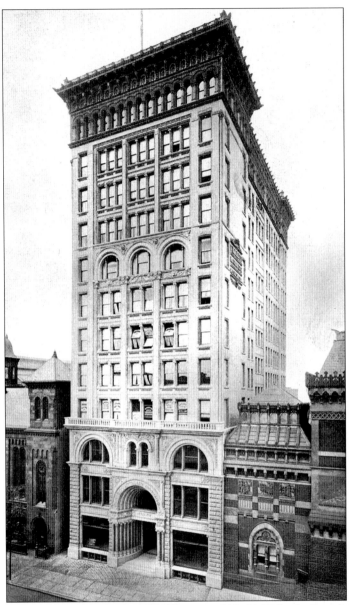

The Fidelity Mutual Life Association's building, at 112–116 North Broad Street, is still standing today but hardly noticed because it is overshadowed by the United Gas Improvement Building next door. Built in 1894, the office building was designed by F.S. Newman of Springfield, Massachusetts, in an eclectic mix of styles that includes a front entrance in the Romanesque style. Newman designed the fireproof building with four elevators, steam heating, electric lights, letter chutes, and fireproof and burglarproof vaults on all the office floors. Rentals ranged from $228 to $7,000 per year, which included filtered ice water for the tenants. In this 1897 view, the Academy of Fine Arts is shown on the right, and the First Baptist Church, at the northwest corner of Broad and Arch Streets, is on the left. One year later, in 1898, First Baptist Church was demolished to make way for the new United Gas Improvement Building. Consequently, many of the windows on the south side of the Fidelity Bank Building were now facing a blank wall.

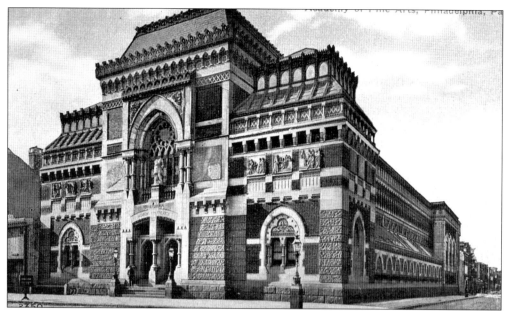

The Pennsylvania Academy of Fine Arts is one of America's oldest art institutions. In 1876, the academy opened its present home at Broad and Cherry Streets. Its High Gothic polychrome design is one of architect Frank Furness's greatest works. The headless antique statue of the Greek goddess Ceres stands above the front portal. Flanking Ceres are two blank stone panels that still wait to be carved into sculpture.

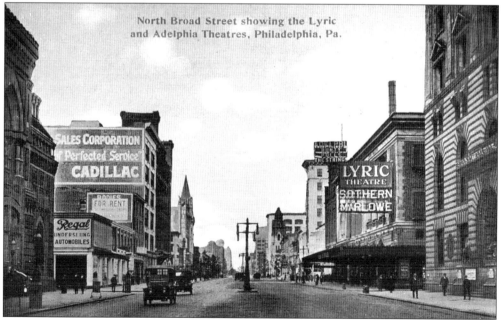

Opposite the Academy of Fine Arts is the Odd Fellows Temple, designed by Hazelhurst and Huckel in 1893 and now altered, at 121 North Broad. On the next block were two theaters that shared a common facade and canopy designed by architect James H. Windrim. The Lyric opened in 1905 and Adelphi (not Adelphia) in 1907. They were torn down in 1937, casualties of the Great Depression. North Broad Street's "Automobile Row" started from here.

67

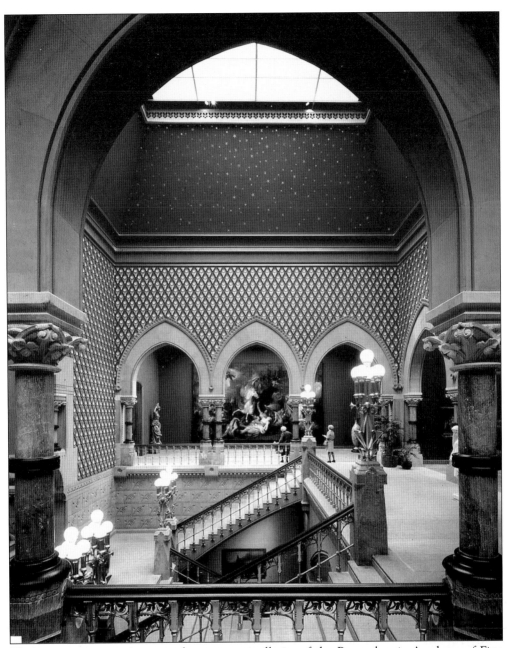

The great entrance staircase to the upper art galleries of the Pennsylvania Academy of Fine Arts shows architect Frank Furness's attention to every ornamental detail. Before electric lighting, Furness lighted this grand space from above by large skylights and gaslights mounted on the stair balusters. In 1976, the exterior and interior of the academy was meticulously restored to its former glory by VITTETA architects under the supervision of head restoration architect Hyman Myers. (Courtesy VITTETA; photograph by Harris-Davis.)

Hahnemann Medical College was founded in 1848 as a medical college teaching the homeopathic medical treatments developed by German physician Samuel Hahnemann. In 1885, architects Hewitt and Furness designed this Gothic-style building just north of Broad and Race Streets. Like many public buildings of the period, it had its decorative tower.

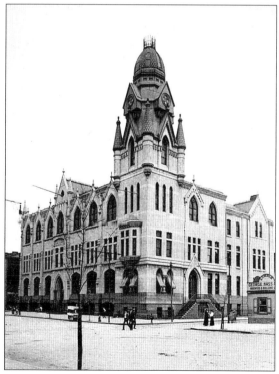

Still standing, but without its tower, is Roman Catholic High School, at the corner of Broad and Vine Streets. In 1878, it was endowed by a bequest from Thomas E. Cahill, making it one of the first free parochial schools in the country. In 1895, architect Thomas Lonsdale designed the building in a Victorian Gothic style. George Nass's lumberyard, seen opposite the school, is a remnant from the days when train tracks ran down North Broad Street.

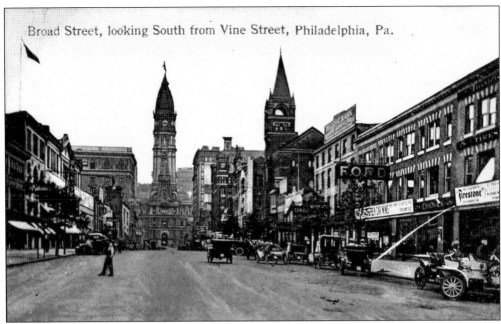

By 1910, North Broad Street had become known as Automobile Row. This 1910 postcard of North Broad Street, looking south from Vine Street, shows the many automobile dealerships and automobile supply stores that already lined the street, including Ford, Oldsmobile, Hudson, Locomobile, Autocar, Buick, and many others. On the right is the tower of Hahnemann Medical College.

This 1915 postcard of North Broad Street, looking north from Race Street, shows a policeman directing automobile traffic before there were stoplights. Light standards were in the middle of Broad Street, and automobiles, no longer a rarity, were parking between them. The tower of Roman Catholic High School is seen in the distance, with the new eight-story Packard Motor Car Company building just behind it.

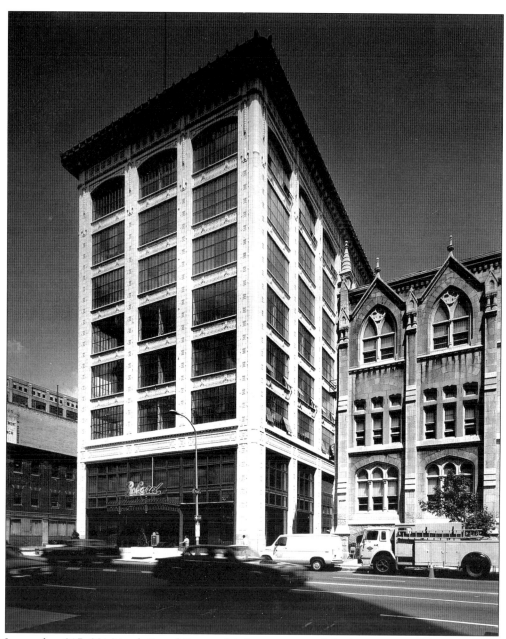

Located at 317–321 North Broad Street, this former automobile showroom and factory is now Packard Apartment Building. It was originally designed by Chicago engineer Albert Kahn in 1910, for the Packard Motor Car Company as its major showroom on Automobile Row. Kahn designed the building in reinforced concrete covered with decorative terra-cotta tiles and large industrial windows for natural lighting. In 1927, the main showroom floor was redesigned by architect Philip Tyre. In the 1980s, the architectural firm of Bower Lewis Thrower renovated the building for loft apartments, restoring the building's classically inspired terra-cotta exterior and handsome entry canopy to once again reaffirm Packard's presence on North Broad Street. To the right can be seen Roman Catholic High School. (Courtesy Bower, Lewis, and Thrower; photograph by Peter Olson.)

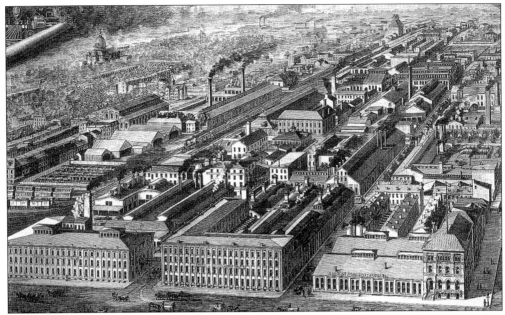

In 1831, Baldwin Locomotive Works was founded by Matthias Baldwin, who built the first American locomotive in Philadelphia. The works grew into a huge industrial complex spreading from the southwest corner of Broad and Spring Garden Streets and covering 17 acres. In busy years, Baldwin Locomotive Works turned out 2,500 locomotives a year, or an average of eight per day. It employed 19,000 men and shipped locomotives as far away as Siberia and Argentina. For many years, Matthias Baldwin's statue stood in the center of Spring Garden Street facing his creation; his statue was later moved to City Hall Plaza. Below is a 1907 postcard view of Baldwin Locomotive Works taken of the southwest corner of Broad and Spring Garden Streets, now the site of the State Office Building.

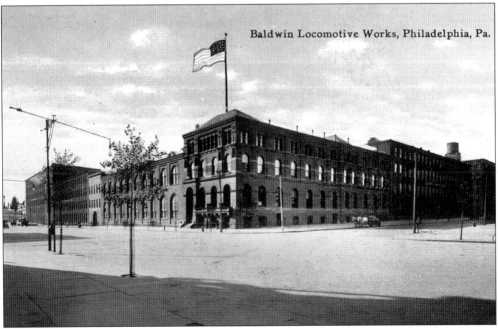

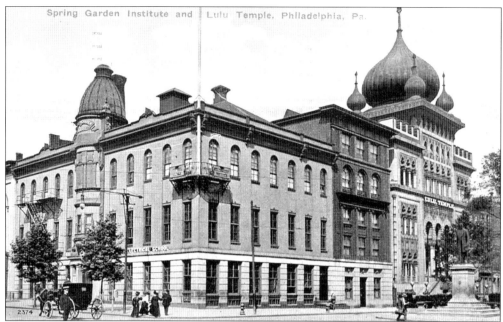

The First New Jerusalem Society building was built in 1851 at the northeast corner of Broad and Spring Garden Streets and was designed by architects Hoxie and Button. It is better known as the Spring Garden Institute, a technical school for apprentices in art, electricity, and mechanics. It was also the first home of the Young Men's Hebrew Association, which leased space from the institute from 1875 to 1883. Matthias Baldwin's statue is shown in the center of Spring Garden Street.

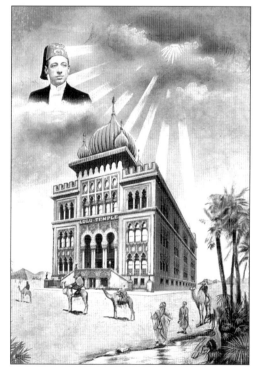

The postcard view on top also shows the Lulu Temple, at 1337 Spring Garden Street. The Lulu Temple was built in 1903 in a very appropriate Saracenic style. It is also featured in this 1909 fantasy postcard with the Grand Potentate of Lulu Shrine wearing a fez and floating above the Lulu Temple.

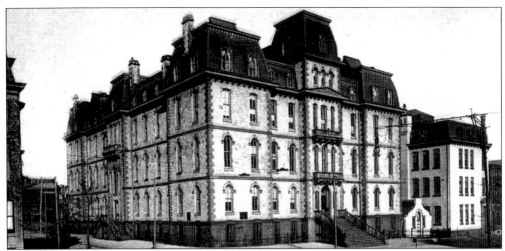

The Girls' Normal School, built in 1876 at Seventeenth and Spring Garden Streets, had 900 students when it opened and graduated almost 100 students that year. The school was designed by architect Lewis H. Elser in the Second Empire style with curving mansard roofs and a central tower. When the new Normal School for Girls opened in 1893, the school's curriculum became purely academic, and it was renamed Girls' High School.

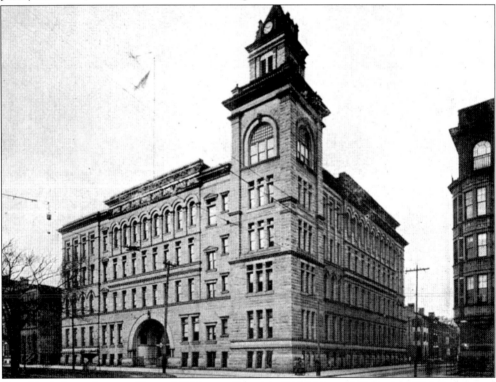

One block from the new Central High was the new Girls' Normal School at Thirteenth and Spring Garden Streets. By 1900, the old Girls' Normal School had tripled in enrollment, and a new Romanesque granite building, designed by architect Joseph Anshutz, was built. The school had a 1,400-seat assembly room, a large gymnasium, library, and four scientific laboratories. The normal school trained young ladies to teach grammar school.

Rodeph Shalom Synagogue, with its polychrome facade, was erected in 1869, the same year this lithograph was made. The synagogue was designed by architects Fraser, Furness, and Hewitt. Located at Broad and Mount Vernon Streets, the synagogue was built on the east side of North Broad Street so the congregation would be facing east toward the Tabernacle. Every successive synagogue built on the street followed this tradition.

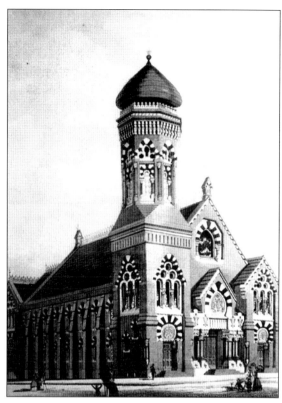

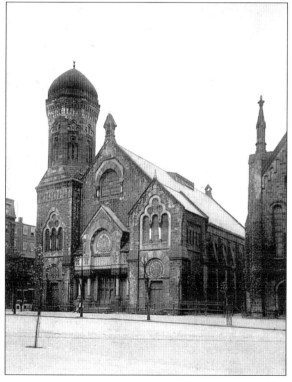

Rodeph Shalom's unique Saracenic style established itself as a traditional synagogue design repeated in Philadelphia and in New York City. By 1905, when this postcard view was made, its bright-colored facade had become gray with soot. To the right, part of the North Broad Street Presbyterian Church can be seen. Rodeph Shalom Synagogue was demolished in 1926 to build its present building, which was designed by architects Simon and Simon.

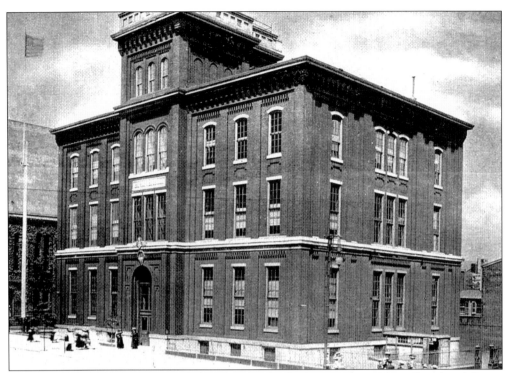

Above is the second home of Central High School, which opened in 1854 at Broad and Green Streets. It was designed by architect Samuel Sloan, and the total cost of the school, site, and equipment was $75,000. Central was called the "Peoples College," conferring a bachelor of arts degree on its graduates, including the author of this book. The list of graduates from this unpretentious building reads like a *Who's Who* of 19th-century Philadelphia: Dr. David Solis Cohen, manufacturers Samuel S. Fels and Albert H. Disston, merchants Ellis Gimbel and Joseph Snellenberg, artists Louis Glackens and Thomas Eakins, and almost every Philadelphia lawyer, judge, educator, doctor, bank and insurance company president. Below is a 1900 photograph of Central's distinguished faculty. Seated in the chair of honor is Prof. Zephaniah Hooper, graduate of Central's first class in 1842.

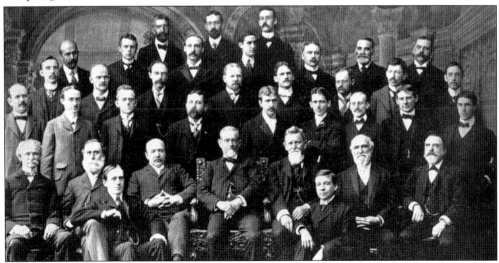

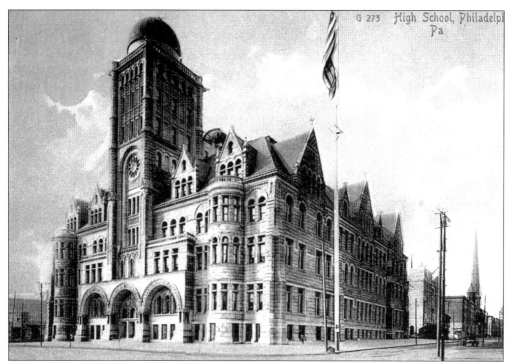

The third home of Central High School covered an entire block at Broad and Green Streets. Board of education architect Joseph W. Anshutz designed it in a Richardson Romanesque style, with Tiffany windows and a tower topped by the observatory dome. The school's construction was finished in 1900, and the construction costs totaled $1,130,000. The lot cost $400,000, such an unusual circumstance that it started a litigation that received national attention.

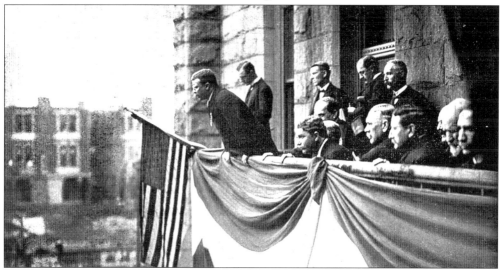

At the school's dedication on November 22, 1902, Pres. Theodore Roosevelt gave his famous "Don't flinch don't foul" speech to 1,500 Central High students gathered below. The man seen at the president's right recorded the speech. On the balcony are Mayor Ashbridge, members of the president's cabinet, and other dignitaries. Central High School remained in this building until 1939, when it again relocated to its present home on West Oak Lane.

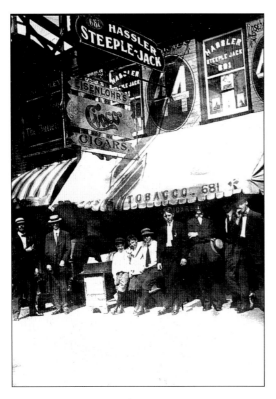

This 1909 photographic postcard was taken by an amateur photographer. His friends are in front of a cigar store at 681 North Broad Street. Kodak would print you photographs on postcard stock if you requested it when you returned the box camera with the used film to Kodak for processing. This rare postcard is a wonderful glimpse into everyday life at that time.

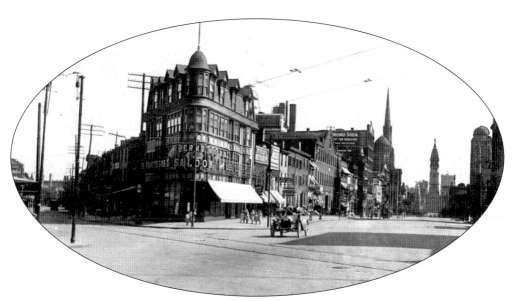

The same photographer took this photograph of Broad Street and Ridge Avenue, looking south toward the Philadelphia City Hall tower. The 600 block of North Broad Street was a commercial block with a large stable in the middle. The domed tower of Rodeph Shalom Synagogue and the tall spire of the North Broad Presbyterian Church can be seen in the distance on the left. Central High's observatory tower is on the right.

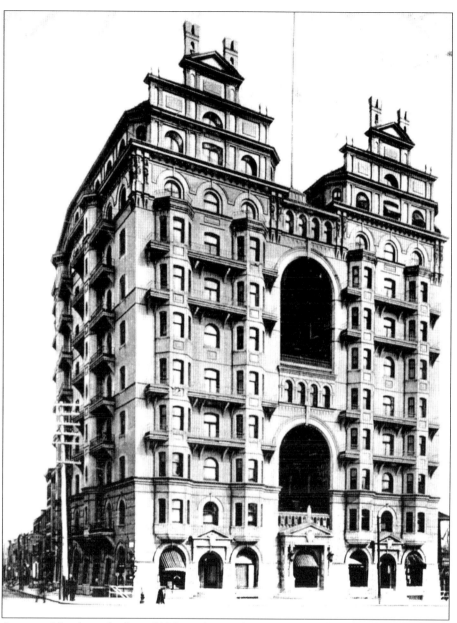

The Lorraine Hotel was built in 1894 on the southeast corner of Broad Street and Fairmount Avenue. Architect Willis Hale designed a fireproofed building with massive bearing walls. Each room had a private bath, and suites facing Broad Street had fireplaces. A separate annex building in the rear was for servants traveling with their employers. In the 1920s, the Lorraine added two hotel garages. In 1948, Father Divine's Peace Mission bought the Lorraine Hotel and changed its name to the Divine Lorraine Hotel, making it the first major hotel in Philadelphia to be integrated. The hotel was rehabilitated in 1948 and again in the 1990s, when it was brought up to present high-rise fire codes by architect Robert M. Skaler. The Divine Lorraine Hotel remains standing today thanks to Father and Mother Divine's concern and continuing maintenance of the hotel through the years. The hotel was sold in 2003 to a developer of historic properties.

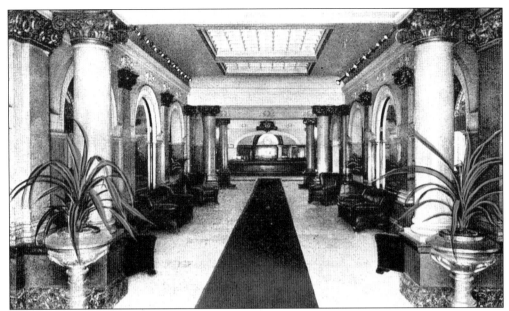

This c. 1910 postcard view shows the Lorraine Hotel lobby as seen from the hotel's Broad Street entrance. The entrance corridor had a skylight, and public dining rooms were on either side. It looks much the same today.

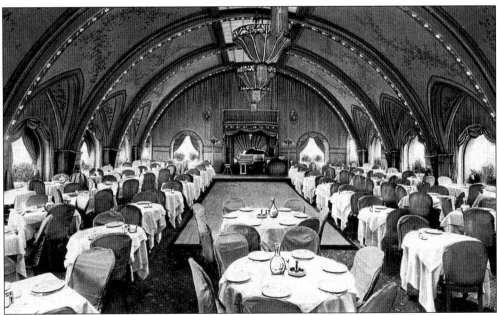

The Hotel Lorraine had two large public rooms on the 10th floor. Most elaborate was the Café Lorraine, which in its heyday had a six-piece orchestra that played from 6:00 p.m. to 1:00 a.m. and, starting at 9:00 p.m., had a cabaret and dancing. The room, which had skylights, seated 300 people and had great views of downtown Philadelphia, to the south, from its many large, round-top windows

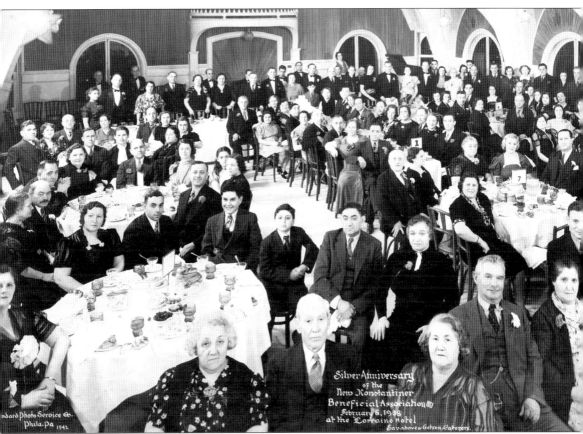

In the 1930s and 1940s, North Broad Street's Majestic Hotel and Lorraine Hotel hosted many Jewish organizations' social functions. This panoramic picture was made on February 6, 1938, at the Lorraine's rooftop ballroom. The occasion was the 35th anniversary of the New Konstantiner Beneficial Association, a social and burial organization of *landesmann* (a Jewish word meaning "fellow land man") from the same eastern European town. The two young boys seated at the table in the foreground are the author's older brothers, Walter (left) and Philip; seated next to them are their parents, Louis and Minnie Skaler.

Originally built in 1877 as the Central Presbyterian Church at 714 North Broad Street, this church has been home to three religious denominations. From 1910 to 1972, it was Our Lady of the Blessed Sacrament, a black Catholic congregation. Currently, it is the Great Exodus Baptist Church. The church was designed in a Romanesque style by architects Collins & Autenreith. The right-hand tower's spire was never completed.

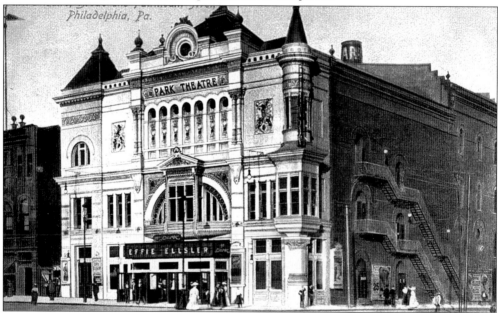

This 1905 postcard view is of the Park Theater, which was built in 1889 at Broad Street and Fairmont Avenue. The Park could seat 1,694 theatergoers. Theater architect J.B. McElfatrick designed the Park with an unusual white brick facade. In 1918, philanthropist John Wanamaker purchased the theater and donated it to the Salvation Army, who altered the building into a YMCA. It was demolished in 1968 for a new Salvation Army building.

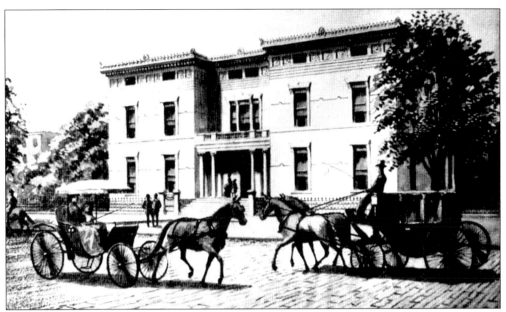

On October 4, 1882, Charles J. Harrah obtained the controlling stock interest of the Peoples Passenger Railway Company and became the company's president. The wealthy Harrah rewarded himself in 1887 with a magnificent new mansion, decorated by artist George Herzog and surrounded by gardens that occupied more than half the block from Broad to Carlisle and Parrish to Poplar. In 1909, it was demolished to construct the Metropolitan Opera House.

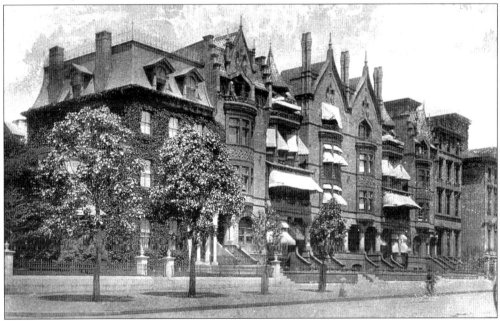

This is the northwest corner of Broad and Poplar Streets as it looked in 1898. The six large five-story houses were designed by architect Willis Hale in his signature Queen Anne style. Hale designed many blocks of row houses in North Philadelphia for Peter A.B. Widener, whose mansion he also designed on the next block at Broad and Girard Avenue. None of these houses is still standing.

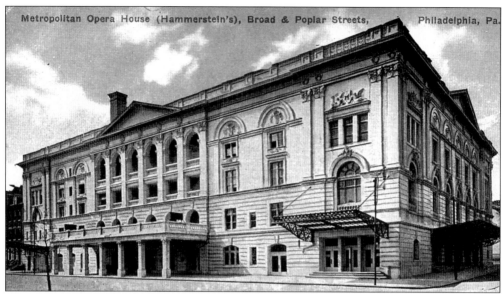

To exploit the competition between North Broad Street and Center City, in 1908, Oscar Hammerstein decided to build a 4,000-seat opera house to compete with the Academy of Music. The Metropolitan Opera House's opening coincided with the beginning of the academy's opera season. Philadelphia newspapers covered this social extravaganza with the gusto of today's Oscar awards. Hammerstein hired the leading theater architect, William McElfatrick, who designed the largest stage in the Philadelphia to accommodate grand opera sets. However, in 1920, opera performances ended, and the once elegant hall was used as a basketball court in 1939, a ballroom in 1943, and finally for religious revivals. The much altered "Met," seen below in a 1930s photograph, still stands but in a ruinous condition, waiting to be restored. The Met made its movie debut as the desolate theater interior in the film *Twelve Monkeys*.

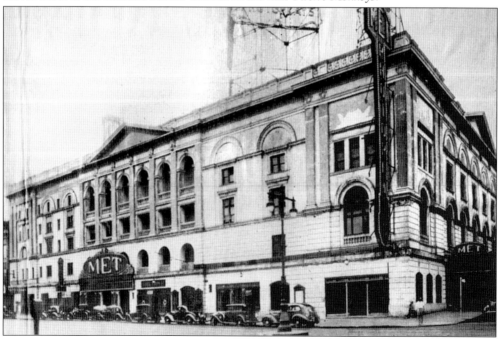

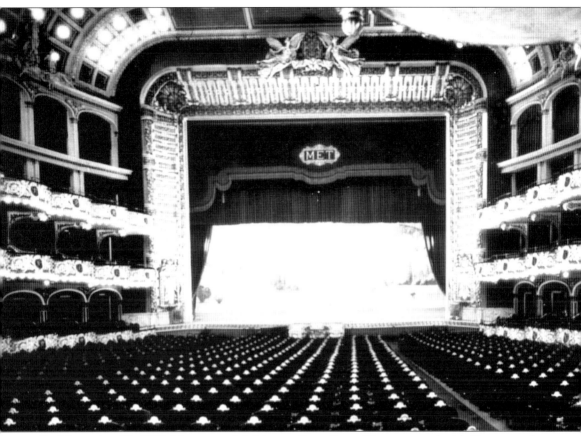

On November 17, 1908, Hammerstein's Metropolitan Opera House opened with *Carmen* and a cast of 700. That same night, the Academy of Music opened its season with the great tenor Erico Caruso. The rivalry between the two opera houses was at last put to the test. The academy's 3,000 seats were sold out. Nevertheless, at intermission, the audience left, rushed to their waiting carriages and cars, and headed north on Broad Street to arrive in time to see the second half of *Carmen*. Hammerstein purposely delayed the opera's intermission, thus filling all 4,000 seats of the Met. It was a draw, and contrary to newspaper predictions, Philadelphia society did go uptown. However, it was a hollow victory for Hammerstein, for in five years the opera house was bankrupt and sold, never reaching its high point again. (Courtesy Irving R. Glazer Collection.)

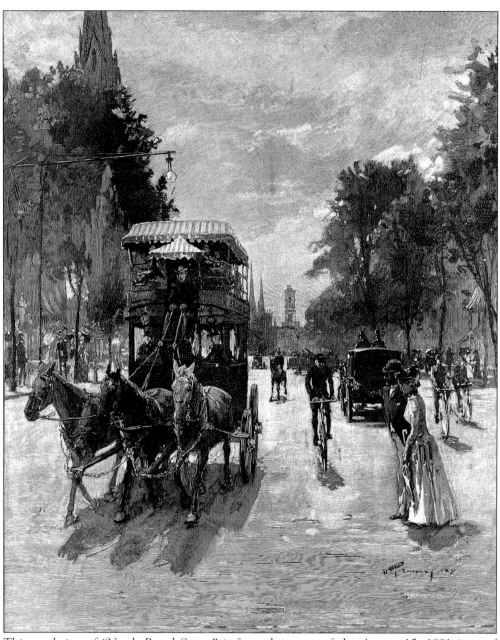

This rendering of "North Broad Street" is from the cover of the August 15, 1891 issue of *Harper's Weekly* and was created by the well-known Victorian artist W.T. Smedley. Although Smedley took some artistic license with his sketch, he did capture the excitement of the street as a fashionable promenade and a wide thoroughfare perfect for bicycling or taking a carriage ride. In the center of the picture is the Philadelphia City Hall tower, which at that time was still under construction. Spring Garden to Susquehanna Avenue was the "Park Avenue" of Philadelphia. Four-story brownstones lined both sides of the street, interspersed with mansions and gardens, and punctuated by clubs, churches, and synagogues. The residents of North Broad Street were undoubtedly people of means but not considered high society by the old Philadelphia elite who lived south of Market Street, ensconced around Rittenhouse Square.

Born in 1834, Peter A. Brown Widener held his first job in a butcher shop. In 1875, Widener, William L. Elkins, and William H. Kemble obtained the controlling interest of one of the most important street railways in Philadelphia. The syndicate soon controlled 527 miles of street railways in different cities, 200 in Philadelphia alone. In the 1890s, Widener and Elkins, who were both serious art collectors, lived across from one another in huge, art-filled mansions at Broad and Girard Avenue. The two families were united in 1883, when George D. Widener, the second son, married Eleanor Elkins, daughter of his father's friend and business associate, William L. Elkins. Widener died in 1915, of natural causes at age 78, leaving a fortune of $100 million, equivalent to $21 billion today.

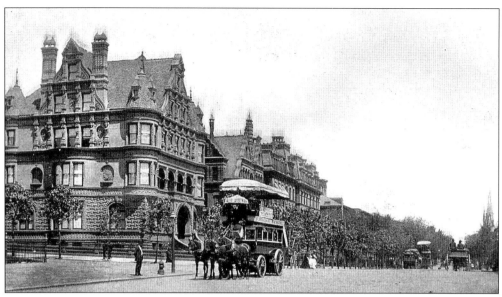

In 1887, Peter A.B. Widener, one of Philadelphia's wealthiest men, built his mansion at the northwest corner of Broad and Girard Avenue. Architect Willis G. Hale, who designed many projects for Widener, designed the mansion in a picturesque Germanic Queen Anne style. A two-story brick conservatory and art gallery was added in 1892 to accommodate Widener's growing art collection. In 1900, the Wideners moved to a grand new estate in Cheltenham. They donated the house to the city as the Josephine H. Widener Memorial Library. The house was demolished in 1972. Only a small piece of the stonewall flanking the sidewalk entrance to the Broad Street Subway remains to remind us of its past glory.

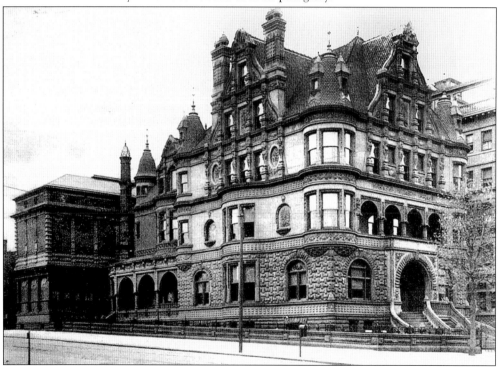

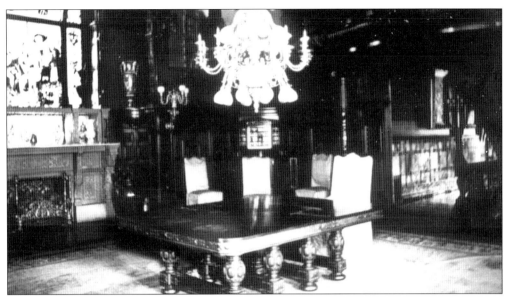

Peter A.B. Widener hired George Herzog to design the interiors of his new mansion. Above is the dining room, with elaborate stained-glass windows located over a fireplace that is filled with cast-iron gas logs. The gasolier over the dining room is both gas and electric. The alabaster-walled entrance vestibule can be seen on the right. Barely visible above the dining room entrance is the stair gallery from which musicians would play during formal dinners. Below is Widener's picture gallery that was added to the rear of the house in 1892. It was lighted by skylights and both gas and electric lights. P.A.B. Widener's family continued collecting only the works of the great masters, such as Rembrandt and Van Dyck. The art collection is now in the National Gallery in Washington, D.C.

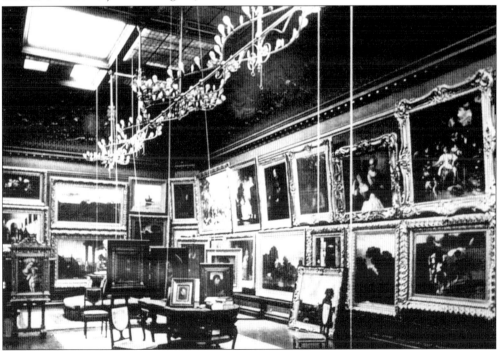

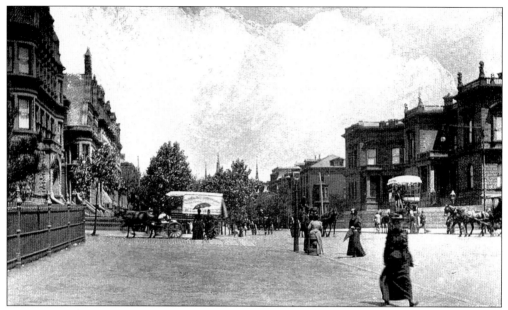

William Luken Elkins, business partner to Peter A.B. Widener, built his mansion across from the Widener mansion, at Broad and Stiles Streets. The mansion is seen on the right in this 1898 photograph. The house was designed by architect William B. Powell in 1889. Both Widener and Elkins soon outgrew their Broad Street homes and moved to suburban estates. In 1900, Elkins moved to Elstowe Manor, his palatial estate in Elkins Park.

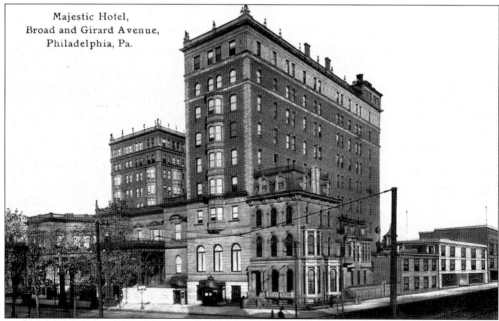

In 1902, the Majestic Hotel was built at Broad and Stiles Streets, incorporating the Elkins Mansion into its design. Architect Joseph M. Huston, who also designed the Pennsylvania State Capitol Building, used the grand living spaces of the Elkins Mansion for public parlors. The Majestic provided all the services of a grand hotel and apartment house, with an elegant dining room and a French café. It is no longer standing.

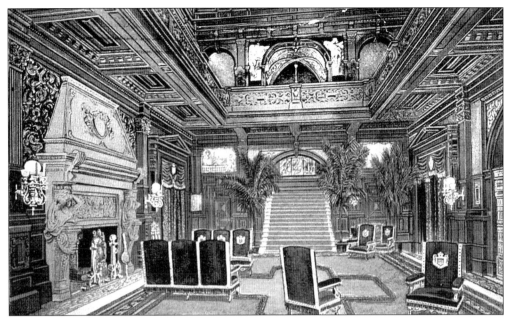

The Majestic Hotel lobby (above) and the music room parlor (below) are seen in 1907 postcards views. The two rooms are parts of the former Elkins Mansion that were incorporated into the Majestic Hotel, designed by the architect to be used as public spaces. These elegantly furnished rooms provided the Majestic's wealthy guests with the same decor they would have had at home and to those who were not accustomed to such luxury, the feeling that they were guests at a millionaire's house.

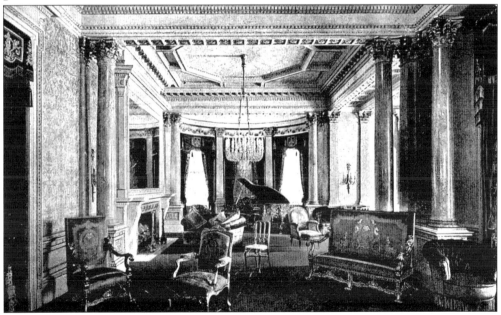

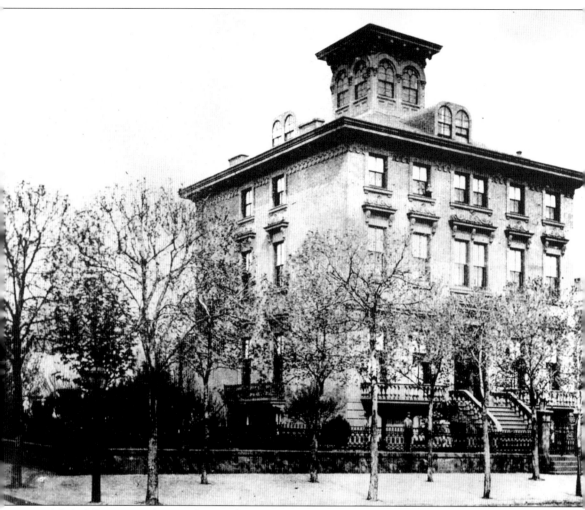

Michel Bouvier, cabinetmaker, real estate entrepreneur, and great-grandfather of Jacqueline Bouvier Kennedy, built this Italianate-style villa with a rooftop cupola, c. 1854, at the northwest corner of Broad and Stiles Streets. He moved here from his large townhouse at 260 South Third Street, which is still standing. Located in what was then suburban North Philadelphia, Bouvier's villa had a large garden with cast-iron urns and sculptures surrounded by an elaborate wrought-iron fence and gates made by Robert Wood & Company of Philadelphia. Note the rows of trees on the Broad Street sidewalk. (Courtesy La Salle College Archives.)

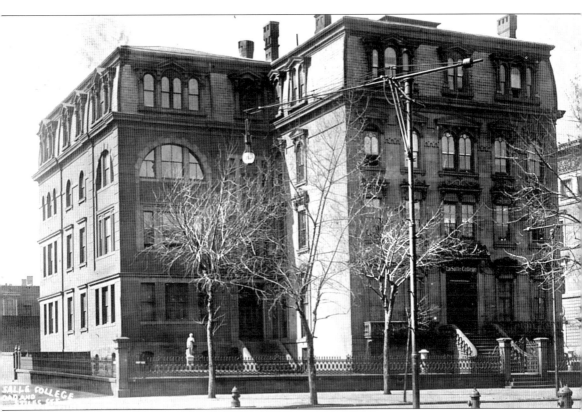

Having outgrown its second home at Juniper and Filbert Streets, La Salle High School College purchased Michel Bouvier's uptown villa located on the northwest corner of Broad and Stiles Streets for its third home in 1882. Architect Edward Durang, who did many projects for the archdiocese, was chosen to design (with assistance from architect John Deery) a new addition in 1886, seen here on the left. As the all-boys school grew, a gymnasium was added on the rear of the building. In 1897, a matching mansard-roofed fourth floor was built onto the entire structure. In 1930, LaSalle moved to its present home near Germantown. The Foederer Mansion can be seen on the right.

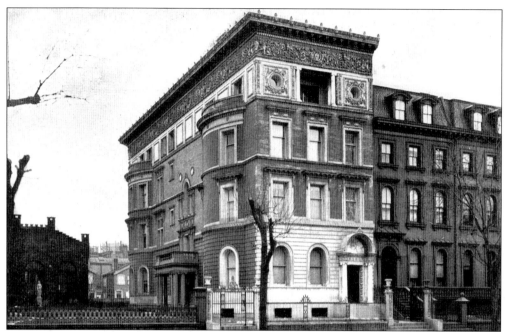

This is the home of Hon. Robert H. Foederer, a congressman at large, located at 1246 North Broad Street as it looked in 1902. Foederer also owned a kid-leather-manufacturing plant that had 1,768 employees in 1902. The Renaissance Revival house designed by architects Hazelhurst and Huckel in 1894 towered over the adjoining brownstone row houses. The architects faced the mansion to look over LaSalle's garden.

Now forgotten, quiet little Ontario Park was between Thirteenth and Watts Streets and Stiles and Thompson Streets. It was at the rear of the great mansions that once lined the east side of the 1200 block of North Broad Street. Their rear verandas overlooked this beautiful park. The side of the Majestic Hotel is visible in this 1907 postcard. Sadly, Ontario Park no longer exists.

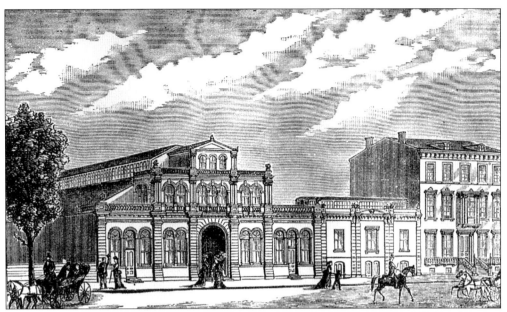

The 1876 engraving above shows the Forrest Mansion when it was a restaurant. Next door was the temporary Women's Centennial Concert Center Garden Building, which was built just for the centennial. The brownstone Italianate villa at Broad and Masters Streets has had a checkered existence. Built in 1854 for William Gaul, a wealthy brewer, it became the home of Edwin Forrest, famed tragedian, from 1855 to 1872. In 1876, the mansion became a restaurant and was later used for church services. In 1880, it became the home of the Philadelphia School of Design for Women (now the Moore College of Art), and a large rear addition was added to the house by architect John H. Windrim. The 1930s postcard below shows the Broad Street facade of the mansion and Edwin Forrest's original theater addition on the left. Today, the Freedom Theater occupies the site.

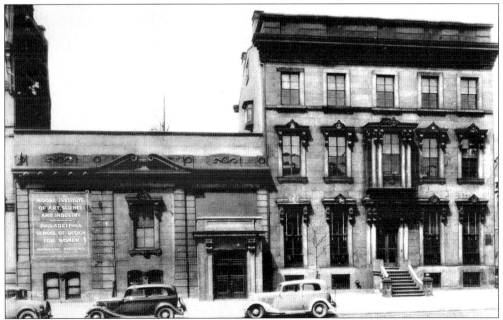

The Philadelphia School of Design for Women, at Broad and Masters Streets, is seen in this 1920 aerial view, taken from the Memorial Baptist Church. At the extreme left are three large brownstone mansions (built in 1865 at 1312–1316 North Broad Street) that were combined into the Loyal Order of the Moose lodge in 1914 by architect Carl Berger. The lodge became a social cabaret in the 1950s. Since 1961, it has housed the Legendary Blue Horizon, the No. 1 boxing venue in the world and the last boxing venue of its kind in the United States. It was the filming site of *Rocky V*. The Memorial Baptist Church (below), built in the 1890s, once stood at the northeast corner of Broad and Master Streets. It was enlarged in 1899 by architects Rankin and Kellogg. It was later named the Philadelphia Gospel Tabernacle.

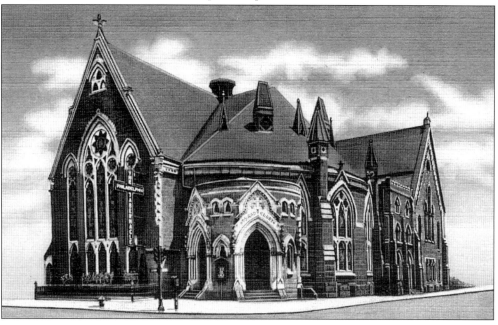

Five

THE GRAND PROMENADE: MASTER STREET TO SUSQUEHANNA AVENUE

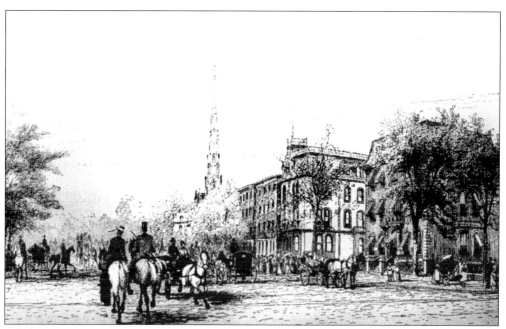

While the old Quaker City was somber and quiet on the sabbath, North Broad Street, on the other hand, was alive with carriages, riders, and strollers. Victorians loved to promenade in their Sunday best while admiring the gardens and grand houses that lined North Broad Street. The Disston mansions can be seen on the right. This engraving was made in 1876, when North Broad Street was the place to be seen on a Sunday afternoon.

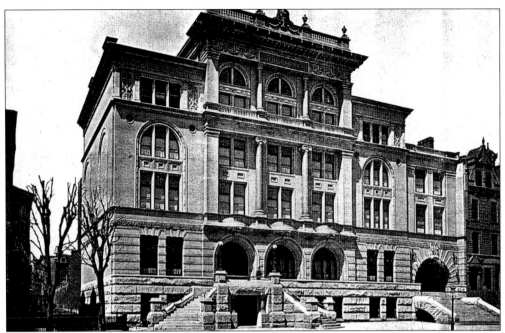

The neoclassical Mercantile Club opened in 1894 at 1422–1426 North Broad Street. It was the merchants and manufacturers club for uptown's affluent families of German-Jewish descent, including the Snellenbergs, Gimbels, Fleishers, and Mastbaums. A competition for the club's design was held in 1892 and was won by architects Baker and Dallett, who designed the club's interiors as elegant as those found in the elite downtown Philadelphia clubs. (Courtesy Jewish Archives.)

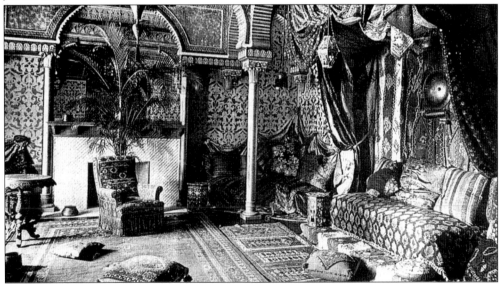

Every public room of the Mercantile Club was decorated in a period style. The club's extravagantly decorated Turkish-nook smoking lounge was done in a Saracenic style made popular by architect Frank Furness at the 1876 Philadelphia Centennial Exposition. The room's style became a design fad in the 1890s and had more to do with smoking Turkish tobacco than with the forbidden interiors of Ottoman Empire harems. (Courtesy Jewish Archives.)

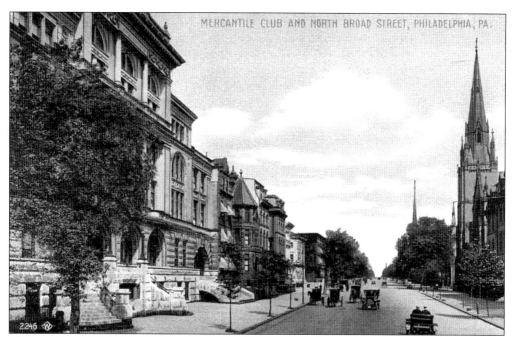

The 1400 block of North Broad Street is shown in 1908 during its heyday. The Mercantile Club is on the left. Next to the club are the Craven House at 1428, built in 1890; the Ellis Mansion at 1430, seen below; and the Winpenny House at 1432, built in 1870. All are still standing. At Jefferson Street was the Incarnation Protestant Episcopal Church, which was built in 1870 and designed by architect Samuel Sloan.

In 1890, traction and lumberyard owner Charles Ellis purchased a double lot at 1430 North Broad Street and hired architect Will Decker to design this Romanesque Revival mansion. It cost $55,000 to build and had every modern convenience. Ellis had the house's woodwork carved with sculptures of mermaids and sea creatures. The mansion survives today thanks to Father Divine's Peace Mission, which bought it in 1953 and has since meticulously maintained it. (Courtesy Peace Mission.)

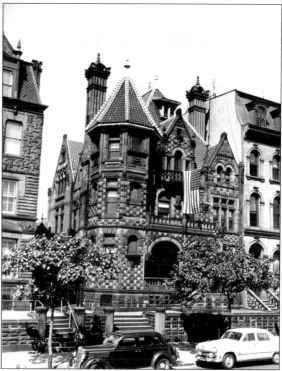

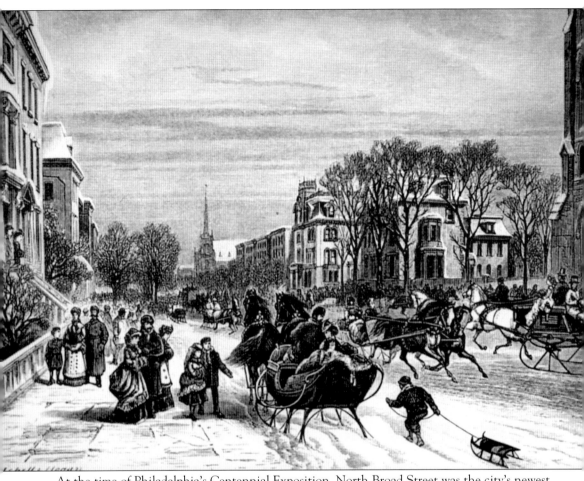

At the time of Philadelphia's Centennial Exposition, North Broad Street was the city's newest and most elegant thoroughfare, lined with the mansions of Philadelphia's entrepreneurs. In this 1876 sketch, Broad and Jefferson Streets are portrayed as grand promenades on a wintry afternoon. Prominently featured in the center of the sketch are the Second Empire–style mansions of Henry and Hamilton Disston, at the northeast corner of Broad and Jefferson. On the southeast corner, to the right, is the Incarnation Protestant Episcopal Church, which was built in 1870. On the northwest corner was the home of newspaper publisher William M. Singerly. In the center can be seen the spire of the Oxford Street Presbyterian Church. Only the Smith Mansion, seen here on the left, has survived into the 21st century.

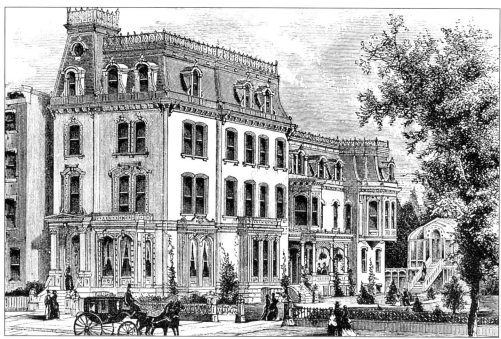

This sketch of the home of Henry Disston, at 1505 North Broad, was in *Philadelphia and Its Environs*, a guidebook published for the 1876 Centennial Exposition. Disston's Second Empire–style home was a landmark on Broad Street, and people came to marvel at its gardens and greenhouse. Henry Disston was the founder of a huge saw and files works in the Tacony section of Philadelphia that employed 2,425 people in 1902, the seventh largest industrial firm in the area at that time. His son Hamilton Disston lived just south of his father's house at the northeast corner of Broad and Jefferson Streets. His house is seen below as it looked in 1903. Hamilton Disston also owned four million acres of Florida land, making him one of the largest individual owners of U.S. land. A classic 1960s urban renewal project now occupies the site.

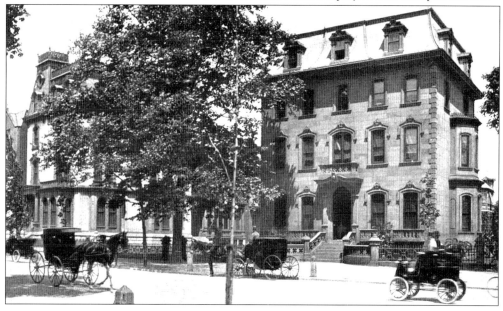

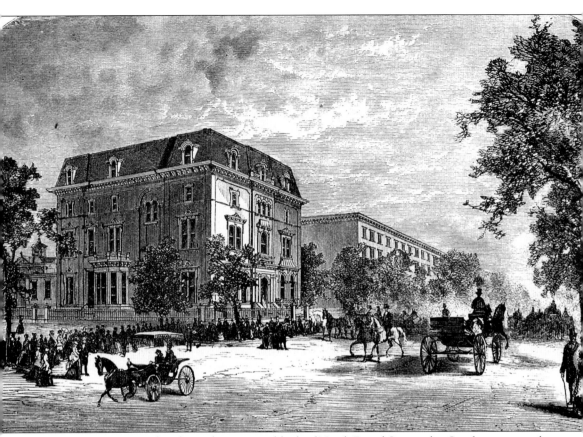

With a prominent church on almost every block of North Broad Street, this Sunday promenade scene was probably not exaggerated. This is the northwest corner of Broad and Jefferson as it looked in 1876. The large Second Empire–style house on the corner belonged to the very wealthy William M. Singerly, owner of the *Philadelphia Record*, one of the city's leading newspapers. The house was probably designed and built by his father, Joseph Singerly, who was an architect and builder. In the 1880s, Singerly purchased 80 acres of farmland in North Philadelphia, lying west of Seventeenth and between Diamond and York Streets. He constructed nearly 1,000 houses on the land. Singerly also owned a farm of 600 acres at the Gwynedd Station of the North Penn Railroad where he raised purebred cattle. His real estate ventures, newspaper, and other enterprises made Singerly a multimillionaire when workers' wages were $1 a day. In 1908, William Singerly's mansion was demolished, and the new home of Alfred Burk was built on the site.

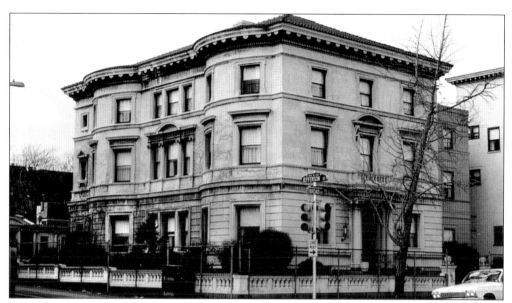

Alfred Burk's mansion was the last great mansion to be built on North Broad Street. Burk owned the block-long Morocco Leather factory on North Third Street in Philadelphia's Northern Liberties section. His house still stands at the northwest corner of Broad and Jefferson Streets, but in poor condition, on the former site of the William Singerly Mansion. The Burk Mansion was designed in 1909 by architects Simon and Basset in the latest Beaux-Arts style.

The Frontenac apartment house was located on the southwest corner of Broad and Oxford Streets. Built in the 1890s, the Frontenac was advertised as an elegant family apartment house "in one of the most attractive neighborhoods uptown: surrounded by handsome and costly mansions." The rent also included meals in a fancy French restaurant on the premises. The Frontenac was demolished in the 1990s.

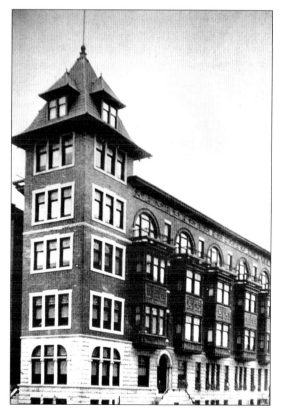

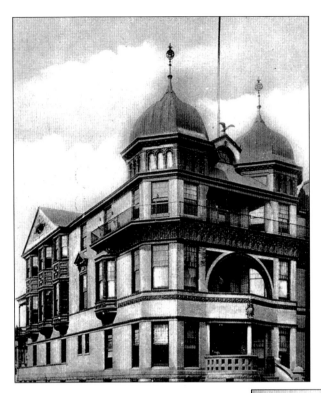

The Columbia Club, on the northwest corner of Broad and Oxford Streets, was opposite the Frontenac apartments. The club was designed in 1889 by architect John Ord, who also assisted John McArthur Jr. with the design of city hall. Ord designed a large Queen Anne–style building in scale with the residences on the block. This uptown club's patrons included many of the industrialists and millionaires who lived on North Broad Street.

Two doors north from the Columbia Club at 1606 North Broad Street was the Century Bicycle Club. Broad Street was one of the few streets paved with asphalt, making it perfect for bicycling. Bicycle clubs were very popular in the 1890s, with both men and women. Bicycling gave women the opportunity for healthy exercise, freedom from wearing corsets, and best of all, the freedom to go out without having a chaperone.

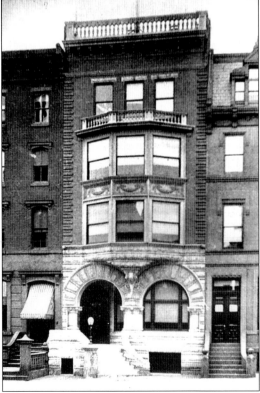

The Columbia Savings Fund, Safe Deposit, and Title Trust Company, on the southeast corner of Broad Street and Columbia Avenue, was designed by architect Will Decker in 1888 with a prominent tower. There must have been some "tower envy" going on among local architects, who designed so many Broad buildings with prominent towers. Towers did serve a purpose, however, by identifying buildings and acting as landmarks at a time when many Philadelphians were newly arrived immigrants who did not speak English.

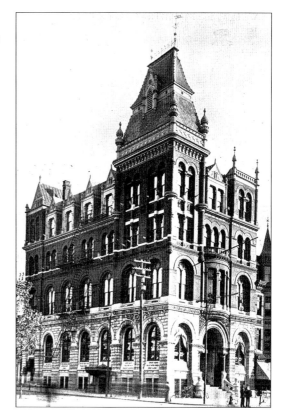

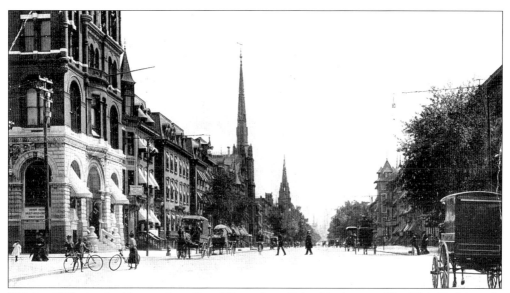

This is a 1908 view looking south on Broad Street from Columbia Avenue. The High Gothic–style Columbia Savings Fund, Safe Deposit, and Title Trust Company is shown on the left. Like exclamation points punctuating the street's skyline are the steeples of the Oxford Street Presbyterian Church at the end of the block and the Incarnation Protestant Episcopal Church at Jefferson Street. On the right-hand side is the Frontenac Apartments at Oxford Street.

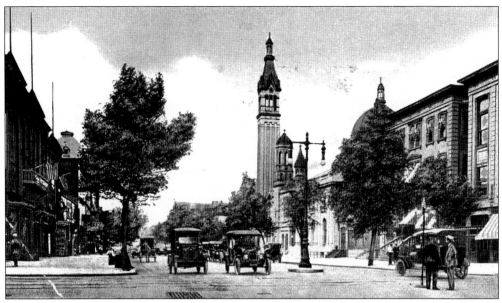

This 1915 postcard view looking north from Columbia Avenue shows the 1700 block of North Board Street. It was very diverse block. On the east side was the Universalist Church of the Messiah, Kenneseth Israel Synagogue, Kenneseth Israel's Alumni Hall, and Philadelphia Turngemeinde Hall; on the west side was the Grand Opera House, Wagner Dancing Academy, North Broad Market, and Betz's Germania Brewery.

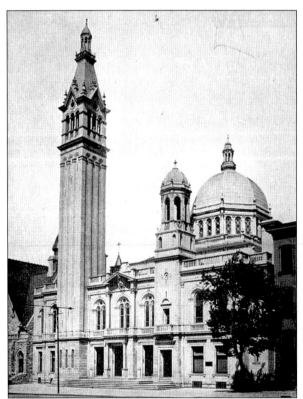

Reform Congregation Kenneseth Israel Synagogue was designed in 1892 by architects Hickman and Frotcher in an Italian Renaissance style. It had 120 feet of frontage on Broad Street with a Venetian-style tower that stood 150 feet high; another tower at the southern end of the facade was 70 feet high. The Alumni Building (not shown), built in 1913 and immediately south of the original structure, is the only building remaining, now called "Rock Hall."

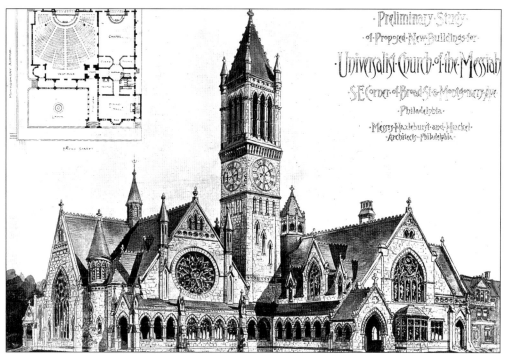

This 1887 drawing made by architects Hazelhurst and Huckel is the preliminary design for the Universalist Church of the Messiah that was to be built at the southeast corner of Broad and Montgomery Avenue the following year. The building stood next to the Kenneseth Israel Synagogue, which was built in 1892, making the block a showcase of 19th-century religious architecture. Below is a 1907 postcard of the first phase of the Universalist Church of the Messiah that was the only one actually completed. The church has since been demolished. (Courtesy Dennis Lebofsky Collection.)

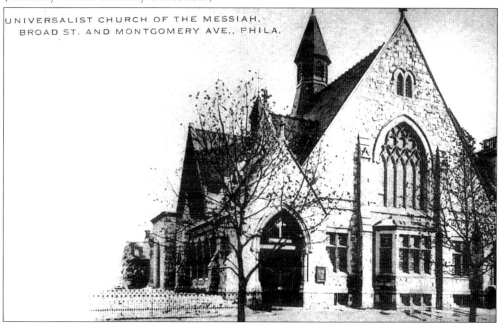

The Grand Opera House, at the southwest corner of Broad Street and Montgomery Avenue, was built by the Betz Germania Brewery and designed by theater architects Hoffman-Henon. It opened on April 7, 1888, with the opera *Tannhauser*. In 1891, the first American performance of *Cavalleria Rusticana,* by Mascangni, opened at the Grand. In this 1888 sketch, the North Street Market can be seen to the left of the opera house. By 1912, Philadelphia could not support three opera houses, so the theater was bought by the Nixon chain and renamed Nixon's Grand. It featured big act names and showed prestigious feature movies that lasted through the 1930s. In 1940, the theater and stage were removed, leaving only the front section standing. The lower floor became the showroom of the Wilkie Buick Company. However, the upper part of the building still looked like the front of a Victorian theater but without its mansard roof. Temple University's Liacouris Center now occupies the site.

AL. CLARK'S IMPERIAL MINSTRELS

DAWSON'S GROTTO
1726 N. Broad Street

MINSTREL AND DANCE

THURSDAY EVENING
April 22d, 1909

In 1909, the southwest corner of Broad and Montgomery was a big entertainment center, and it still is today. Dawson's Grotto, shown above, was in the middle of the block on Broad Street, in front of the Betz Germania Brewery. Betz also owned the Grand Opera House. (Courtesy Dennis Lebofsky Collection.)

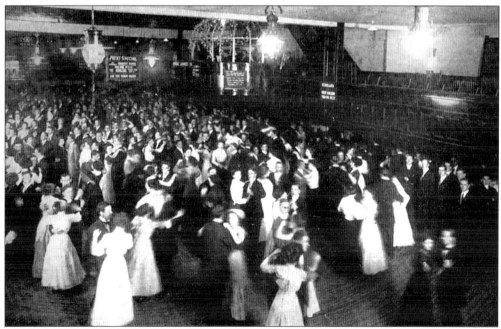

The Wagner Dancing Academy's addresses corresponded to that of the Grand Opera House, which leads one to believe it was probably in a rented space in that building. The windowless space shown in the advertisement postcard below looks like the academy may have been located in the Grand Opera House's ground floor. (Courtesy Dennis Lebofsky Collection.)

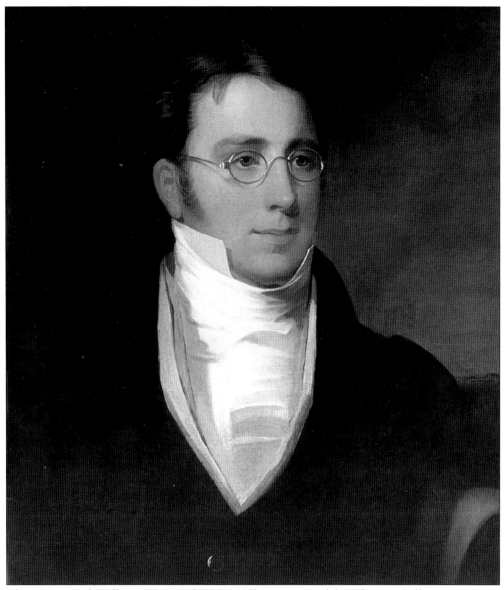

This portrait of William Wagner (1796–1885) was painted by Thomas Sully in 1836 and acquired in 2002 by the Wagner Free Institute of Science, the educational institution and museum that bears his name. Formally incorporated in 1855, the institute had its inception in a public lecture series begun by Wagner in the early 1850s. He was a noted Philadelphia merchant, philanthropist, and gentleman scientist. Wagner was also a lifelong collector of natural history specimens. Through his travels as a trade agent for Philadelphia financier Stephen Girard, he was able to acquire an extensive worldwide collection of specimens. Wagner strongly believed that education of the sciences should be available to everyone and began offering free lectures at his home. By 1855, his lectures, which were free of charge, became so popular that he moved them into a public hall. In 1865, the Wagner Free Institute of Science opened at its permanent home at Seventeenth and Montgomery Avenue. It is still open at the same location, offering free science courses for adults and lessons for more than 9,000 children each year. (Courtesy Wagner Free Institute.)

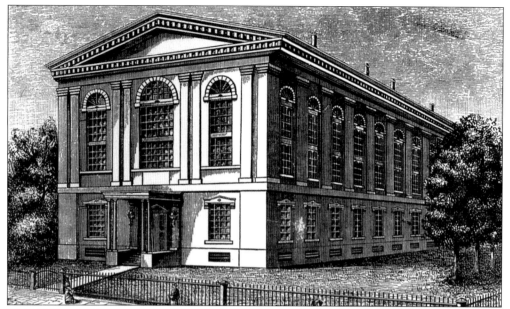

This 1880s woodcut is of the Wagner Free Institute of Science, at 1700 West Montgomery Avenue. The building, designed by John McArthur Jr., the architect for Philadelphia City Hall, was erected during the Civil War on land adjoining William Wagner's estate. North Philadelphia in the 1860s was still undeveloped, so much so that one of the earliest professional baseball fields was located on open field across from the institute. (Courtesy Wagner Free Institute.)

An adult course in the Wagner Free Institute's lecture hall is shown c. 1900. Note that women make up a good percentage of the audience. By the turn of the century, the institute was a leading force in public education in Philadelphia under the leadership of Dr. Joseph Leidy, a biologist of international reputation who headed its programs and reorganized the displays. The institute's natural history museum has more than 100,000 specimens.

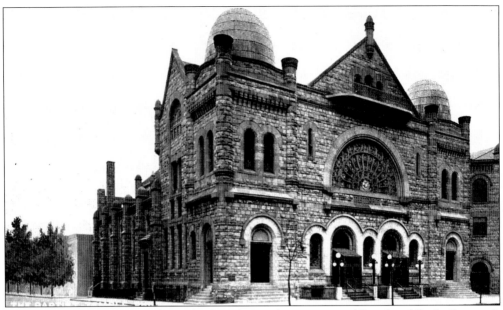

In 1881, Grace Baptist Temple was built at the southeast corner of Broad and Berks Streets. It was designed in a Romanesque style by architect Thomas Lonsdale. Russell H. Conwell, the pastor of Grace Baptist Temple, also founded Temple University and was the school's first president. Conwell was a famed orator, with a huge following, who raised millions of dollars for the school with his classic "Acres of Diamonds" speech, which he delivered more than 6,000 times urging audiences to find riches in their own backyards. In May 1895, the first evening law classes were held in College Hall, Temple's first academic building. Forty-six students enrolled, paying tuition of $12 a semester. Below is the Baptist Temple's great auditorium, which seated more than 4,000 people. It was filled to capacity every Sunday with people eager to hear the great orator Russell Conwell preach.

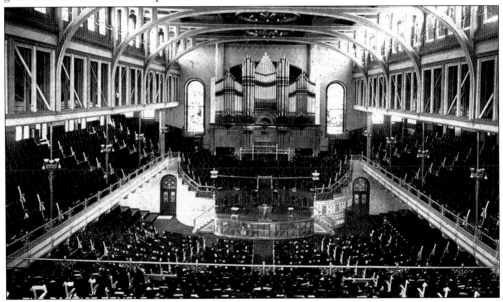

Temple University's Conwell Hall, at Broad and Montgomery Avenue, was built in 1927 and designed by architect William Howard Lee. He also designed Carnell Hall and many other Temple-related buildings. Conwell Hall and Carnell Hall were to be the first stages of a grandiose design, seen below, for a "Tower of Learning" that was never built.

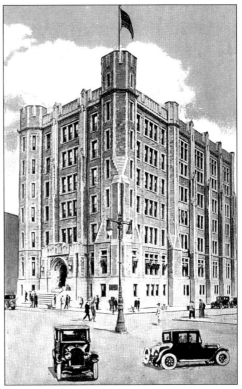

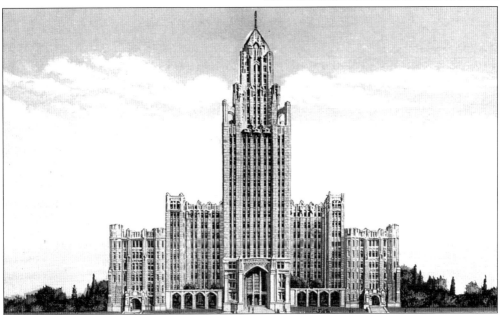

William Howard Lee borrowed heavily for his 1927 design of the proposed Tower of Learning from the 1922 Chicago Tribune Tower Competition's winning design by architect Raymond Hood, which used a similar Gothic flying buttress motif. In the mid-1920s, Temple University considered this five-tower design because enrollment had reached 10,000, and with the opening of the new Broad Street Subway, the school expected to grow even more.

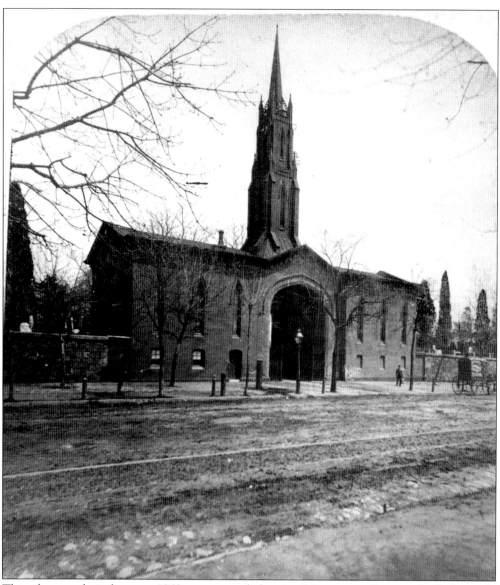

This photograph is from an 1860s stereo card showing Monument Cemetery's Gothic-style entrance gatehouse and chapel, which stood opposite the intersection of Broad and Berks Streets. The gatehouse and chapel were designed by Philadelphia artist John Sartain (1808–1897) in 1836. In the 1860s, the area around Broad and Berks was still rural, north of the developed city. Broad Street, shown above, was unpaved and had railroad tracks in the center leading north to Sedgley Avenue. Monument Cemetery covered approximately a four-block area, situated at a 45-degree angle to the grid pattern of Philadelphia's streets. By 1910, the gatehouse and chapel were demolished, and Berks, Sixteenth, and Seventeenth Streets were cut through the cemetery, breaking it into five parcels. In 1956, Temple University acquired the cemetery and received state permission to remove the bodies and tombstones. Only part of the Broad Street stone wall, seen here, remains. (Courtesy Library Company of Philadelphia.)

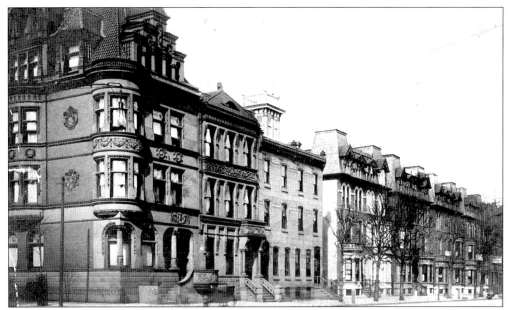

The John Stafford residence, at the northwest corner of Broad and Norris Streets, is now a Temple University fraternity house. Stafford owned a yarns company in Manayunk. Built in 1895 and designed by architect Willis Hale, the house unfortunately no longer has the fourth-floor ballroom seen in this 1907 postcard. At 2002 is the neighboring Gay family's brownstone mansion, which was designed in 1889 by architects Geissinger and Hales.

The remainder of the west side of the 2000 block of North Broad Street was built c. 1870 in the High Victorian Gothic style. Next door to the X-L-N-T Caterers establishment, seen in this advertisement postcard, was the home of Russell Conwell, founder of Temple University, who lived at 2020 North Broad Street. Most of this block is still standing.

115

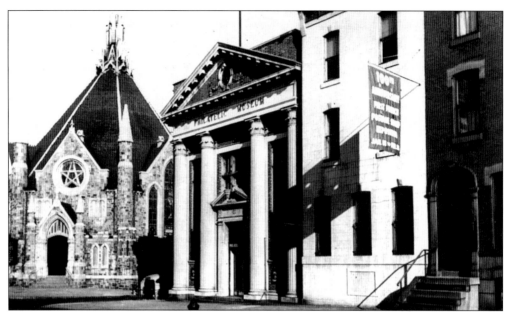

The Philatelic Museum was originally a classical bank building located on the southeast corner of Broad and Diamond Streets. Retired textile-mill owner Bernard Davis, who was also an ardent stamp collector, founded the Philatelic Museum in 1950. It hosted many large expositions and finally closed in 1970. In the background is the Bethlehem Presbyterian Church, which was designed by architect Theopolis Chandler in 1887.

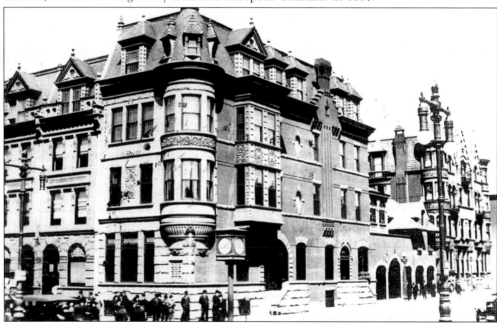

The David H. Schuyler Funeral Home occupied this elaborate Queen Anne–style house at the southwest corner of Broad and Diamond Streets. The garages for the homes' vehicles can be seen in the rear, facing Diamond Street. A street clock advertises the establishment. By 1915, when this photograph postcard was made, several of North Broad Street's larger houses had become funeral parlors.

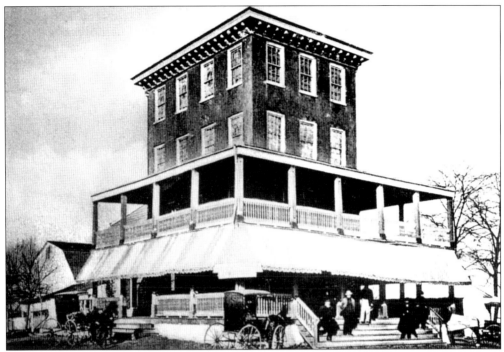

This 1902 postcard of the Punch Bowl was made from an earlier photograph. (The old tavern was torn down in 1892 to build the Second Regimental Armory.) Originally called the Penn Township Hotel, it once sat in a rural setting at Broad Street and Lamb Tavern Lane, north of present Diamond Street. The inn was a favorite spot for travelers and leisure riders to stop and imbibe the famous punch.

The Second Regiment Armory of the Pennsylvania National Guard was built in 1895 and designed with gun ports and towers by architect John Ord. Located on the west side of Broad Street between Diamond Street and Susquehanna Avenue, it was the headquarters of the first regiment of the state militia to use the name "National Guard." On August 7, 1989, the armory had a disastrous fire. A Temple University dormitory now occupies the site.

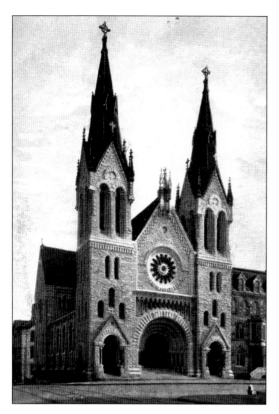

Our Lady of Mercy Roman Catholic Church stood at the southeast corner of Broad and Susquehanna Streets. The parish house was next door. Built in 1895, the church was designed by architect Edwin F. Durang in a Romanesque style. Over the years, the church became as diminished as a sandcastle battered by the sea by first losing the steeple of the north tower, then the entire north tower, and finally, being totally demolished.

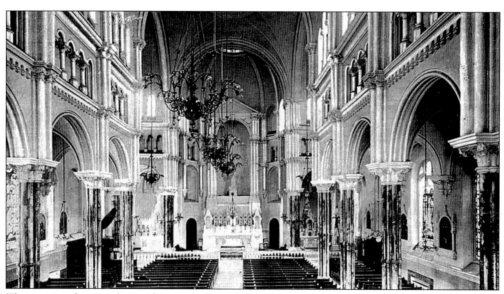

This postcard view shows the once magnificent Romanesque-style interior of Our Lady of Mercy Church. The archdiocese sold the church in the 1990s, and the church was slowly stripped of its ornamentation, furniture, and stained glass. In the late 1990s, through neglect, the north tower collapsed without warning onto Broad Street. Soon after, the building was demolished, a sad end to a once beautiful church.

Six
HUNTINGDON STREET TO OLD YORK ROAD

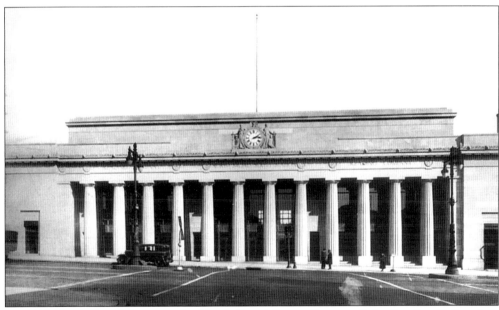

At 2600 North Broad Street is the North Broad Street Station of the Reading Railroad. It opened in 1929 amid much fanfare as one of the country's most beautiful stations. It replaced the old Huntingdon Street Station, which was on the same site. Architect Horace Trumbauer designed the station like a classical Greek temple. Unfortunately, in the 1970s, the station was renovated into a motor hotel; it is now a halfway house for drug offenders. Fortunately, its classical facade has been restored. (Courtesy David Lebofsky Collection.)

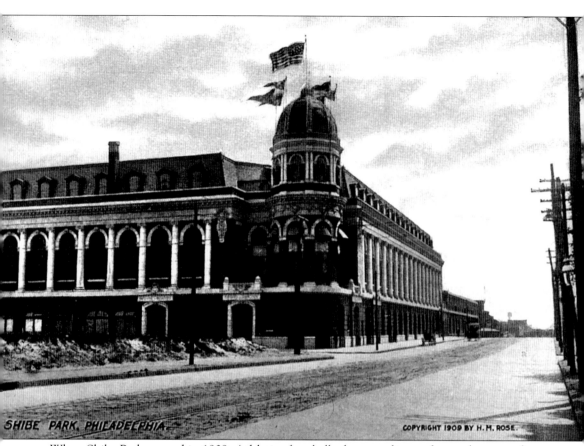

SHIBE PARK, PHILADELPHIA COPYRIGHT 1909 BY H. H. ROSE

When Shibe Park opened in 1909, Athletics fans balked at traveling so far north to a stadium that sat amid open fields. Designed and built by William Steele and Sons, Shibe Park cost $312,000 to build, and it occupied an entire city block at Twenty-first Street and Lehigh Avenue. It was a baseball showplace—the first built entirely of reinforced concrete. The stadium's bleachers were continually being raised in order to keep nonpaying spectators seated on nearby roofs from seeing the baseball games. In 1953, the stadium was renamed in honor of the late Connie Mack, the organizer and manager of the Philadelphia Athletics from 1905 to 1950. After a series of damaging fires, the ballpark was demolished in 1976.

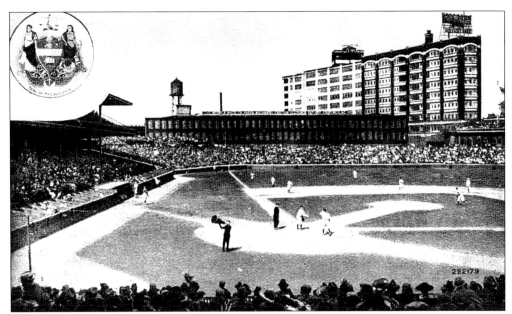

Opposite the North Broad Street Station of the Reading Railroad was the Baker Bowl (Philadelphia Baseball Park), which was located at 2600 North Broad Street. Home to the Philadelphia Phillies, it opened in 1887. In 1915, the park was the site of the first World Series ever attended by a U.S. president. It was also home to the Negro League World Series in 1924–1926 and site of Babe Ruth's last major-league game in 1935. It was rebuilt in 1938 and demolished in 1950. (Courtesy Howard Watson Collection.)

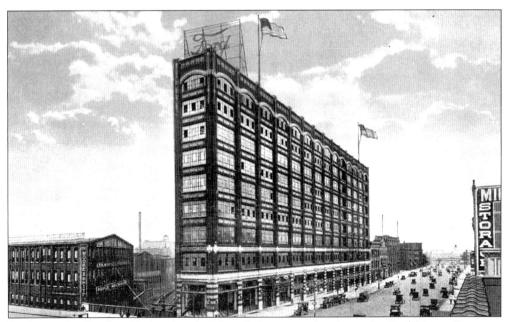

Bordering the Reading Railroad with sidings below street level was the Ford Motor Company Building at 2700 North Broad Street. Built in 1910 as a Ford assembly plant, it had large industrial windows to bring in lots of natural light. Ford remained in the building until 1926; later it became the Botany 500 clothing factory. To date, it is vacant and derelict.

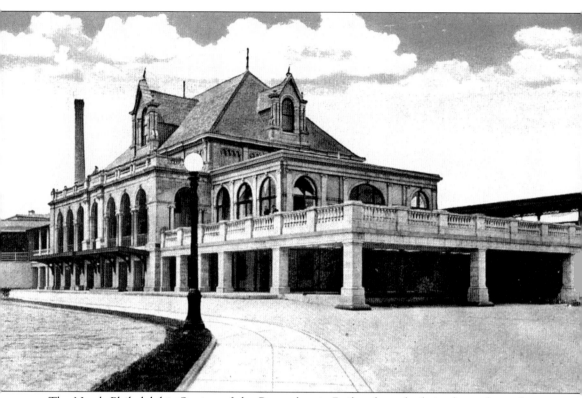

The North Philadelphia Station of the Pennsylvania Railroad was built in three phases from 1896 to 1915 for the east-west train traffic, such as the Broadway Limited, which stopped only at the North Philadelphia Station on its runs to and from New York City. Architect Theopolis Chandler designed an elegant French Renaissance station with terraces for the passengers to walk out on from the waiting room. The station's platform was featured in a scene in the 1945 movie *Pride of the Marines*. After years of neglect, the station has recently been renovated into a shopping center.

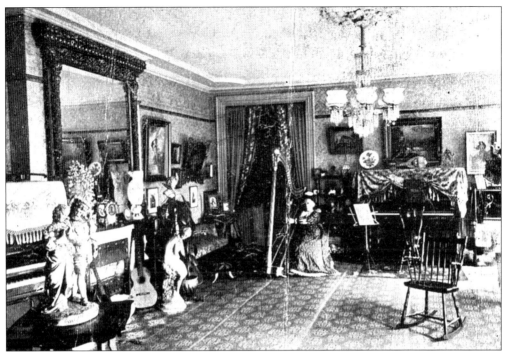

Even in the early 1900s, some of the large houses on Broad Street were being used for professional purposes. This is a 1904 advertisement postcard for E.K. Peall Conservatory of Music and Art at 3304 North Broad Street. Mrs. Peall is shown playing her harp in the Victorian Music Room, where she taught everything from banjo to trombone, elocution, vocal sight singing, impersonation, languages, and painting.

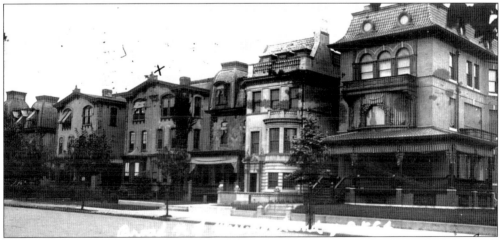

Across from Mrs. Peall's school were these large homes on the east side of Broad Street, north of Westmoreland Street and the intersection of Rising Sun Avenue. Their architectural style indicates that they were built as suburban villas in the 1870s, when this was the edge of the developed city. The two houses at the corner were built in the 1890s. On the northern end of this block at Ontario Street was the Masonic Home.

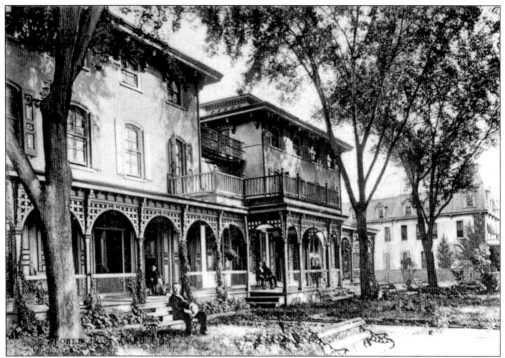

The Masonic Home, which was located at 3333 North Broad Street on the southeast corner of Ontario Street, was dedicated on New Year's Day 1885. It was run by subordinate lodges to the Grand Lodge, which bought the properties for $23,000. Originally two separate Italianate villas, the buildings were connected by the Masons to accommodate 18 retirees. This 1901 postcard shows how suburban this area of North Broad was in the early 1900s.

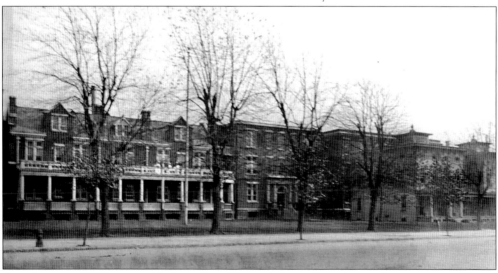

Seen here in a 1913 postcard is Samaritan Hospital, located on the northeast corner of Broad and Ontario Streets across from the Masonic Home. Russell Conwell's Temple Baptist Church started the hospital in 1892 as a community hospital. When Temple University Medical School opened in 1901, the hospital became a teaching hospital. In 1930, Samaritan Hospital changed its name to Temple University Hospital.

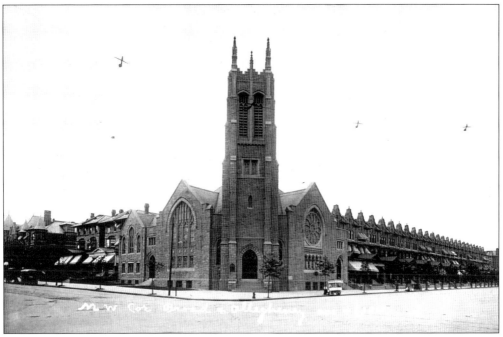

The North Muchmore Presbyterian Church, at the northwest corner of Broad Street and Allegheny Avenue, was built in 1909. It is now the Greater Ebenezer Baptist Church. The large homes that once graced the 1500 block of Allegheny Avenue can be seen in this 1910 postcard. Entire blocks of large houses on Broad Street north of the church have since been demolished.

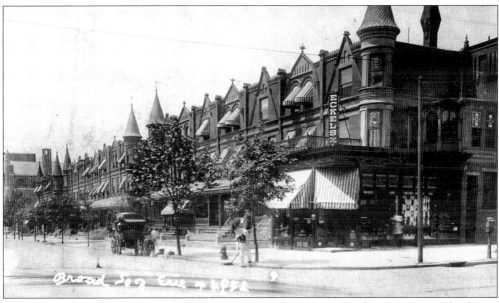

This 1910 postcard view shows the west side of Broad Street south of Erie Avenue. This house design is typical of the many blocks of houses built c. 1900 on this stretch of North Broad Street. As the area became run down, the homes were eventually purchased by Temple University Hospital and demolished for its expansion.

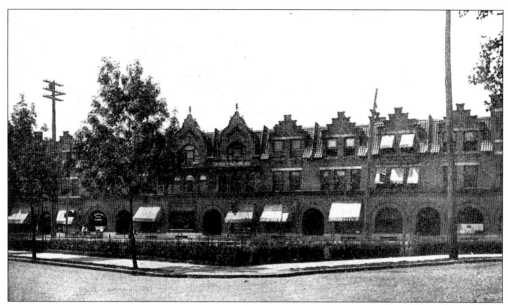

Where Erie and Germantown Avenues cross Broad Street was the site of Markley's Tavern in the 1870s. The area was so rural at the time that it was used as a track for horse races. In the 1890s, the Queen Anne–style commercial block visible in the background was built. In 1908, the city built this small park on a triangular lot at Broad and Butler Streets for a total of $877. The commercial block is standing today but is hardly recognizable due to demolition and modernization.

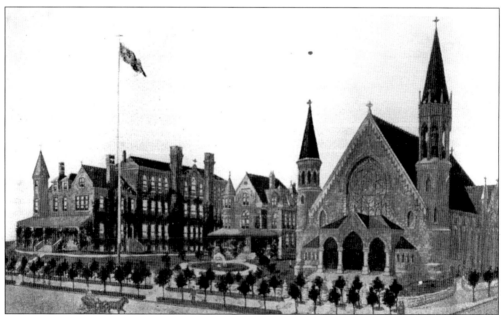

St. Steven's Roman Catholic Church and the adjoining rectory and school, located at the northwest corner of Broad and Butler Streets, were built in 1894. Architect Frank R. Watson designed the church and auxiliary buildings in a Victorian Gothic style. In 1905, the church bell towers were built, and in 1907, the interior of the church was completed. (Courtesy Philadelphia Archdiocesan Historical Center.)

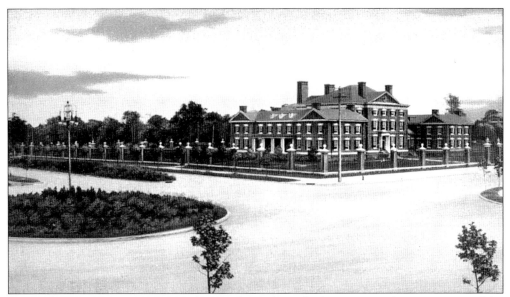

The William L. Elkins Masonic Orphanage for Girls was built in 1904 at the intersection of the new Torresdale Boulevard (now Roosevelt Boulevard) and Broad Street. The intersection at that time had a landscaped circle in the middle of Broad Street. Architect Horace Trumbauer designed the orphanage as a beautifully fenced, gated Georgian mansion. It is now the Prince Hall Lodge.

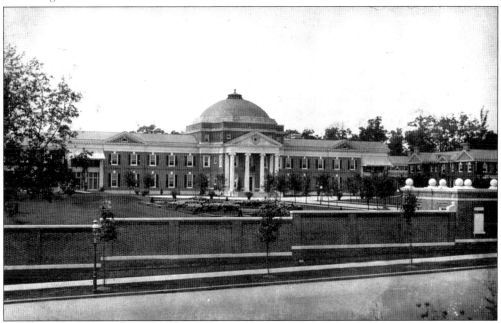

William Elkins and Peter A.B. Widener were both great philanthropists in the days when there was no federal income tax and therefore no tax incentive to be generous. Widener built the Widener Memorial Industrial Training School for Crippled Children at Broad and Olney in 1902. Architect Horace Trumbauer also designed this grand institution, surrounding it with an impressive brick wall that is still standing. The domed, classical building has since been replaced by a nondescript modern building.

ACKNOWLEDGMENTS

This book could not have been written without the cooperation of both friends and institutions that share my interest in Philadelphia history. They include the Philadelphia Archdiocesan Historical Research Center, Philadelphia Historical Commission, Library Company of Philadelphia, Athenaeum of Philadelphia, Jewish Archives of Philadelphia, University of Pennsylvania Archives, Philadelphia Museum of Art Archives, Elks Lodge of Fairless Hills, Wagner Free Institute, Ritz Carlton Hotel, and the Legendary Blue Horizon.

Architectural offices that graciously shared photographs of their work for the book are as follows: VITTETA; Hillier; Bower, Lewis, and Thrower; and Kise, Straw, and Kolodner. Thanks go to photographers Tom Bernard and Tom Crane, who gave permission to use their architectural photographs, and historian Jefferson Moak.

A special thanks go to David Rowland, president of the Old York Road Historical Society, whose assistance has been invaluable, as well as Father and Mother Divine and the Peace Mission; James Mundy, archivist of the Union League of Philadelphia; Brother Joseph Grabenstein, archivist of LaSalle College; Carol Ann Harris, Temple University archivist; Laura Libert of the Masonic Temple of Philadelphia's Archives; Jose A. Rodriguez; and fellow postcard enthusiasts Howard Watson and Dennis Lebofsky, who graciously lent rare postcards from their collections for this book.

The Jewish Hospital was surrounded by fields when it opened in 1871, located at what was the end of Broad Street—the intersection of Olney Avenue and Old York Road. This 1905 postcard shows the Home for the Aged, built in 1871, on the right; the new Guggenheim wing is on the left. Architects Furness and Hewitt designed both buildings. Einstein Hospital now occupies the site.